AMERICAN MASTERS

Selections from the

Richard Lewis Hillstrom Collection

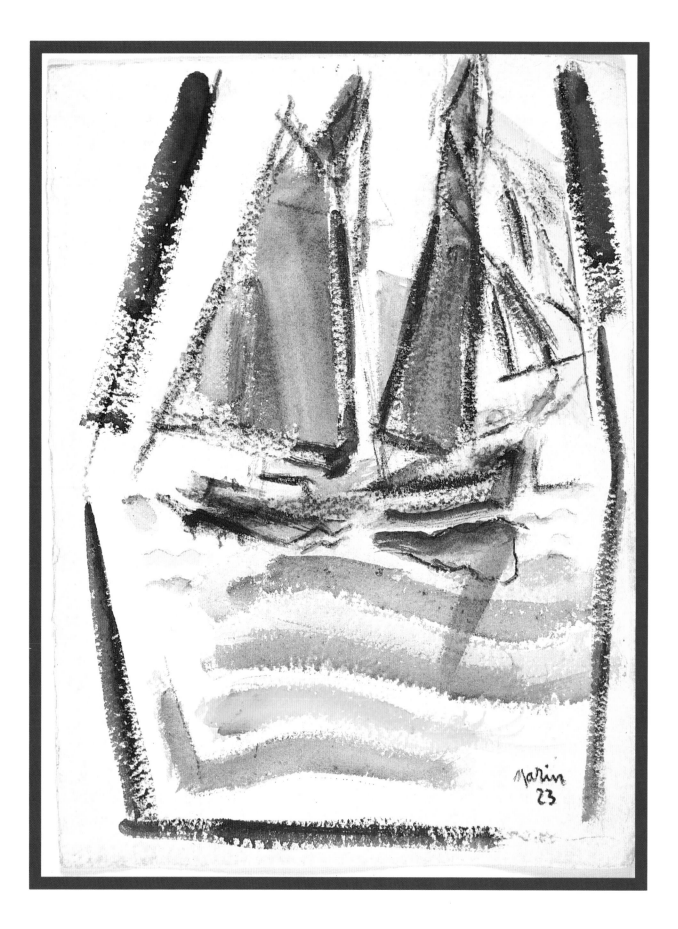

AMERICAN MASTERS

Selections from the
Richard Lewis Hillstrom Collection

Dennis Michael Jon

The Minneapolis Institute of Arts

This book was produced in conjunction with the exhibition
American Masters: Selections from the Richard Lewis Hillstrom Collection
The Minneapolis Institute of Arts
April 23–July 3, 1993

Edited by Sandra L. Lipshultz
Designed by Ruth Dean
Photographs by Robert Fogt
Type set by Lynne Cason

Library of Congress Catalog Card Number 93-77784
International Standard Book Number 0-912964-54-5

Cover:
Reginald Marsh
Manhattan Towers

Frontispiece:
John Marin
Stonington Harbor, Deer Isle, Maine

Foreword

The Reverend Richard L. Hillstrom has been an important presence at The Minneapolis Institute of Arts for many years. For over four decades, he has played a vital role as adviser, donor, and friend to the museum and especially to the Department of Prints and Drawings. His deep interest in art has been developed over a long time, and as a passionate collector of American art and especially drawings, Richard Hillstrom has brought to our community a wonderful resource that he very generously shares through this exhibition. While this museum continues to build its American collection, Hillstrom's concentration on the twentieth century has given us prime examples from a very vital and creative period that documents 1930s regionalism and the American scene.

There are many ways to build a collection, and Mr. Hillstrom has been able to face these challenges with extraordinary concentration and devotion. In the catalogue's interview, he tells of the financial constraints he was under, collecting at a time when the prices of American art were considerably lower than today but on a budget commensurate with his position as a minister. Given this situation, his collection remains all the more remarkable and stands as a tribute to his unfailingly keen eye and strongly defined sense of quality.

Private collections provide an interesting portrait of an era as well as a documentation of an individual's specific tastes and personal view of the history of art. The Hillstrom collection allows us to glimpse our past and to see how American artists responded to their social and natural environments. As we look at these works, they also serve as reminders of both our differences and our commonalities as Americans through two centuries. While the art is as varied as its subject matter, one thing that binds it together is the artists' mutual experience as Americans and their devotion to the creative spirit.

Richard Hillstrom's artistic choices reflect his work in serving the emotional and spiritual needs of people as well as his personal sensitivity to art as a creative expression of the human condition. We are deeply indebted to Mr. Hillstrom for his years of help and support of this museum and for this wonderful opportunity to share the joys of his collection with our public.

Evan M. Maurer
Director
The Minneapolis Institute of Arts

Richard L. Hillstrom and Evan M. Maurer

About the Collector

Born and raised in rural Dassel, Minnesota, fifty miles west of the Twin Cities, Richard Lewis Hillstrom left his hometown after completing high school to attend Gustavus Adolphus College in Saint Peter, Minnesota. Upon graduation in 1938, he entered the Augustana Seminary in Rock Island, Illinois. Ordained as a Lutheran minister in 1942, he served as pastor at Bethel Lutheran Church in Gary, Indiana, until 1947. While living in Gary, he began collecting art, especially works by Scandinavian immigrants.

In 1947, Hillstrom returned to his native Minnesota and accepted a position as assistant pastor at Mount Olivet Lutheran Church in Minneapolis, where he remained for five years. Then in 1952, he became chaplain for Saint Paul's Bethesda Lutheran Medical Center and later director of chaplaincy services. During the mid-1950s, as his interest in art grew, he began acquiring paintings by such American masters as John Henry Twachtman, Ernest Lawson, and William Glackens. Today, his collection numbers over three hundred pieces and includes works by George Bellows, John Marin, Edward Hopper, Charles Burchfield, Reginald Marsh, Maurice Prendergast, and Isabel Bishop. "The formation of the collection has been exciting and gratifying," he once wrote. "Some works were carefully searched out, others were simply stumbled upon. But the thrill of discovery was always exhilarating."

In 1978, the Minnesota Museum of Art elected him a trustee, a post he presently holds as chair of the collections committee. While in semiretirement in 1982, Hillstrom was asked by Lutheran Brotherhood of Minneapolis to become their first art consultant and in that capacity has built a renowned collection of religious art for them during the past decade. In the early 1980s, he also supported the creation of The Minneapolis Institute of Arts' Print and Drawing Council and continues as an active member of its board. With characteristic generosity, Hillstrom has donated many works to the Institute over the years and in 1982 helped establish an endowment for the purchase of prints and drawings for the museum's permanent collection.

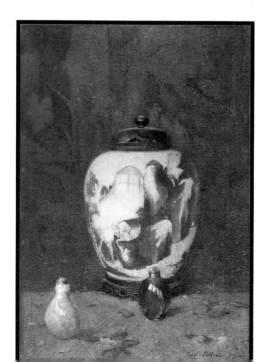

Birger Sandzén
Evening

Søren Emil Carlsen
Still Life, Chinese Vase

A Conversation with Richard Hillstrom

You've been collecting art for many years now and have assembled an impressive collection of American modernism. How did your interest begin?

I can't really say when my interest began, but I do recall from my childhood that we had no original art in our home. Just a few reproductions. However, I do remember asking my mother once, "Why don't we get some new pictures?" So there must have been a little consciousness of paintings, anyway.

Then years later when I was in seminary, a very good friend of mine met Birger Sandzén, a Swedish artist living in Kansas, and ultimately bought one of his works for $125. That was an astronomical amount for a painting in 1939, especially for a student. I suppose I thought to myself, there must be something to this collecting business, to put that kind of time and money into it.

After I finished seminary in 1942 and took my first parish in Gary, Indiana, I had easy access to Chicago and went there almost every week, especially to the Art Institute. There was also another pastor in Gary whose father-in-law had been an art collector. He was particularly interested in the Swedish-American artists in Chicago and had collected some very fine examples of their work. In turn, he'd given a couple of the paintings to his son-in-law, my friend in Gary. I visited him frequently and would see these lovely pictures, and thought how nice it would be to have original art in one's home. So I got the name of one of the artists. He had died, but his widow was still alive, and I visited with her and ended up buying one of her husband's paintings.

Do you remember his name?

Yes, it was Charles Hallberg. I no longer have the painting, but that was the beginning, my first major purchase in about 1944. Then that led to other things. It turned out that Hallberg's widow also had some paintings by Birger Sandzén. Apparently, the two men used to exchange pictures and sell them for each other. When they died, their wives both ended up with some of the other's paintings. I know Hallberg's widow had half a dozen Sandzéns, anyway. So I bought three Sandzéns from her and subsequently also purchased another at auction in Chicago.

Was Evening *one of those paintings?*

Yes. That was the one I bought at auction at the Grant Gallery on Wabash.

Did Grant Gallery specialize in Swedish-American art?

No, Grant was an auction house; they carried everything under the sun there. In fact, I bought a Hallberg from them, too, a large painting which I later gave to the American Swedish Institute in Minneapolis, and one of my Emil Carlsen seascapes, who was Danish-born, although my Carlsen still life came from the Portland Museum in Oregon.

Were there other Chicago galleries you frequented?

Yes. There was another gallery on South Michigan Avenue near the river that specialized in Chicago painters like Adam Emory Albright, who was the father of Ivan Albright. I would also explore the antique shops on North Clark and State streets and often found works by Swedish-American artists there.

Was there a community of Swedish-American artists in Chicago at that time?

Yes, and not just for Swedish-Americans but many Scandinavian artists in general. But the Swedes were particularly well represented with such recognized painters as Hallberg, Alfred Jansson, and Arvid Nyholm. As a student and friend of Anders Zorn, Nyholm, particularly, was a sought-after society portraitist at the time in Chicago.

What was it about the work of these artists that interested you?

Well, you have to begin someplace and since my heritage is Swedish, I was naturally drawn to them. And, of course, I had friends who owned their work, which reinforced my interest in them as well.

And when you moved to Minnesota in 1947, did that change your collecting strategy somehow?

When I moved to Minneapolis, I became interested in the art scene here and started buying works by such local painters as Byron Bradley, Robert Kilbride, John Anderson, and Eric Erickson. Then, I thought, if I'm going to be serious about collecting, I should look beyond the local scene. And I knew I couldn't afford European paintings, particularly French paintings. Yet, I could buy their graphic works. So I began looking for those. Among the first I bought was a Henri Matisse lithograph out of a Walker Art Center exhibition and sale. I also purchased a Marc Chagall print out of that show, which I later sold. Then I really got started. In New York City I bought a couple of prints by Picasso at the Peter Deitsch Gallery. And then subsequently, I also acquired several other prints, including works by Braque, Rouault, Derain, de Chirico, Kollwitz, a Vlaminck which I found in Paris, a small Marquet, several other things like that.

Why did you decide to go to New York to buy art?

Well, I soon discovered that was the source. There were no galleries locally, really, that handled national or international artists at that time.

How often were you able to visit the galleries there?

In the early years, I went almost every year. I started going in 1943 or '44, soon after I was ordained. I used to spend my vacations in Stamford, Connecticut, with a very close friend of mine who was a pastor there. I'd take the train to New York and pound the pavements all day long and come back

Ernest Lawson
Young Willows

John Henry Twachtman
Spring Landscape (Greenwich, Connecticut)

Maurice Prendergast
Cottage at Dinard

exhausted. I'd rest the next day in Stamford and then go down to New York again. And for about two weeks I'd do that. Then, later on, beginning in the late 1950s and into the '60s and early '70s, I was on a commission of our church. And we met twice a year in New York City at church headquarters. I'd always extend my stay there by a couple of days so I could visit the galleries. It was during that period that I acquired most of my European prints and some American works as well.

How did you become acquainted with the New York art dealers?

I just started to walk into the galleries and introduce myself and got to know some of the dealers quite well. In fact, I was amazed at the amount of time they were willing to take with someone who didn't have much money to spend but who was interested. Particularly Carmine Dalesio of the Babcock Galleries. He was really the one who spurred me on. We sat there in that little gallery of his in the back room many times talking about American art and surrounded by the most amazing Eakinses and Homers. I remember one Homer in particular, a small painting, maybe ten by eighteen inches, of a woman leaning against a tree. It was $1,800, which equaled my total annual salary at the time, so my buying it was quite out of the question. But I did finally manage to purchase a painting from Carmine, a small oil by Ernest Lawson called *Young Willows*, a thick impasto which I still have. I think it was one of the first of The Eight that I bought, actually. I remember Carmine saying, "Well, it's small, but it's a big picture, it's got everything in it that Lawson did at his best."

How did you become interested in collecting American art?

In about 1955 or '56, I went on a cruise to South America—down to Rio and Buenos Aires—and it was quite a long trip. There was a book in the ship's library by Sheldon Cheney, his story of

modern art, and I read it avidly from cover to cover. He devoted quite a bit of space to American art with particular emphasis on John Henry Twachtman. I found that very interesting, so I thought when I got to New York again I would check into his work.

So on my next trip there, I stopped to see Harold Milch at the Milch Galleries— he was a well-known American dealer— and I asked him if he had any paintings by Twachtman. And he pulled out this canvas—*Spring Landscape*—which was very impressionistic, almost a blur. Then he said, "You may not believe this, but my father sold this painting years ago for $1,200. But there isn't much interest in Twachtman now, so you can have it for three hundred." Well, I was a little shocked even at that price, but I decided it was worth taking a chance on it, so I had them ship it home. I often said all that I could see when I hung it on the wall was not the painting, but the $300. But I kept it fortunately, and now it has become one of my favorites.

So that was the beginning of my American collection. Then subsequently, I came across works by John Sloan and Maurice Prendergast at the Kraushaar Gallery and then another by William Glackens, who were all members of The Eight. So I had three or four of the group, and I thought I might as well try to have something by all eight artists. I suppose I'm mentally constructed in such a way as to want to formalize things, to complete them.

When did you complete your collection of The Eight?

Well, I can't remember the date, but I do know where. I had six of the eight artists at the time and during a visit to the Graham Gallery asked if they had any works by Everett Shinn or Arthur B. Davies. So they brought out a little Shinn pastel which I wasn't very interested in. Then, one of the assistants said, "Maybe we've got something else." He went into the back room and came out with a Shinn in one hand and a Davies in the other. They had the old

price tags on them, but he said, "That's okay, that's what they are." So I got both of them that very day, and that completed my collection of The Eight.

So then I went on from there, on and on and on, adding many well-known American painters, works by Edward Hopper, John Marin, and Charles Burchfield. Most of these pictures I purchased from Antoinette Kraushaar at the Kraushaar Gallery and John Clancy at the Rehn Gallery.

Was there something specific about these artists' works that intrigued you?

I think it was the subject matter and also that they were American. I suppose I just felt closer to these artists because they were citizens of our own country. And in some cases I was able to meet the artists and gain a better appreciation for their work because of the personal connection. I spent an afternoon with Charles Burchfield in Buffalo, New York, for instance, and a few hours with Aaron Bohrod in Madison, Wisconsin.

How did you meet Burchfield?

I was making a trip to the East Coast in 1964 with a friend at the time of the second New York World's Fair, and we stayed overnight at his parents' in western New York near Jamestown. We were going to New England through Buffalo, and I suggested we try to see Burchfield. So we found the house, a little old frame house in an unpretentious neighborhood. I rapped on the door and timidly introduced myself to Mrs. Burchfield. I told her I owned a Burchfield drawing and would like very much to have a chance to meet him. And she was very hesitant and didn't say anything, but just sort of waited.

Then I remembered that they belonged to the Lutheran Church, and so I explained that I also was a Lutheran pastor. And with that, she said, "Well, Charles isn't working today, so I'm sure it will be all right for you to come in."

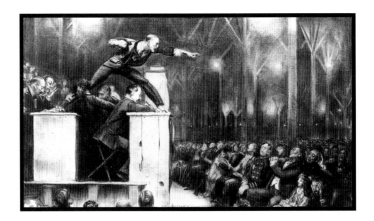

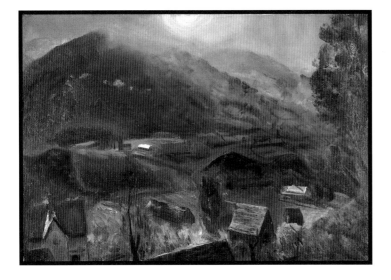

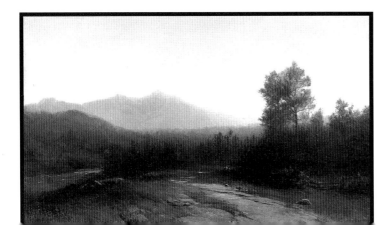

George Bellows
Billy Sunday

George Bellows
Sunset, Shady Valley

Homer Dodge Martin
Hudson River Landscape

took us out to his studio in the back. And I saw things there and in the house, including this great stuffed raven over the window, which I was familiar with from one of his watercolors.

It was a very pleasant experience. He kept pulling out drawer after drawer of his works in these large steel files, and I saw one little drawing I liked very much. So I asked if he ever sold things out of his studio, and he said, no, he'd never done that because he and Frank Rehn of the Rehn Gallery had a verbal agreement that Rehn would be his exclusive dealer. "And neither of us has ever broken that promise all these many years," said Burchfield, so that was that.

Also on the same trip, I spent a Sunday afternoon with Ben Shahn. I'd written to him a couple of months before asking if he had any small watercolors or drawings for sale. He wrote back and said he didn't sell his drawings because he kept them as references for future paintings. But he said, "If you ever come this way give me a call, I'd be glad to see you."

So on the way home, we stopped in Roosevelt, New Jersey, where he lived, and spent a couple of hours with him. And in his living room he had a print of the television antennae they call *Caliban*, which I also owned. I was really pleased to see that because it must have been an indication of his high regard for it if he chose to put it on his own wall. He also took us out to his studio and showed us the stained glass sketches he was working on for a synagogue in Buffalo, New York. I never did hear if it was ever installed or not, but I assume it was. He had a print, a serigraph called *The Blind Botanist*, which he offered to sell me. But I was so set on a drawing, I just couldn't think of anything else, and so I didn't buy it. It turned out to be one of his really important prints, so I've kicked myself around the block many times since for passing that by.

Were there any other American artists who captured your interest during this time?

After I'd filled in The Eight I spun off from this group. And George Bellows came into the picture quite early on. I think the first piece by Bellows I bought was from his dealer Gordon Allison, a drawing called *Tennis Match, Camden*. And that led to another and another and another until I finally had six of his drawings as well as four of his lithographs. For the prints I was thinking of buying everything that had any connection with religion. But I wouldn't call them religious lithographs per se because they were actually parodies on Billy Sunday, who was a traveling evangelist. Bellows did not appreciate people like Sunday at all, and that is evident in his images. I bought *The Sawdust Trail, Billy Sunday*, and *The Benediction in Georgia*, which are all very satirical. I also acquired the lithograph *Crucifixion of Christ*, which was really the only truly religious subject Bellows ever did in any medium.

Would it be fair to say that George Bellows is one of your favorite American artists?

Yes, very much so. I like his work because he painted life and America, and when I started collecting it, I met Gordon Allison of H. V. Allison & Company. He, like Dalesio, was a very accommodating, cordial person who seemed to detect a genuine interest on my part. And because Allison handled Bellows exclusively, I was exposed to quite a lot of the artist's work through him and was able, with a limited budget, to purchase six drawings, several lithographs, and ultimately a painting.

Was the Bellows painting one of your more significant acquisitions?

Yes, the Bellows painting—*Sunset, Shady Valley*—is the crème de la crème of the collection. Partly because it's such an excellent painting and partly because, in my opinion, it's late Bellows at his best. Do you recall reading Washington Irving's *Rip Van Winkle*? One of his opening paragraphs

describes the Catskill Mountains in great detail, with the mist hanging over them and so on. It's almost as if Irving were looking at Bellows's painting when he wrote those words because they describe it so perfectly. Apparently, it's a tiny village very close to Woodstock, New York, where Bellows had his summer studio.

You also have two landscape paintings by Homer Dodge Martin. How did you become acquainted with his work?

I got interested in Homer Dodge Martin because long, long ago I heard he had lived in Saint Paul and was buried there. So I went to the Minnesota Historical Society one day and looked up information on him. And they had quite a folder on him, clippings of newspapers and so on, saying he was born in Albany, New York, where he'd kept a studio, and had died in Saint Paul, where he was buried in Oakland Cemetery. So one day I took my bicycle and rode off to Oakland Cemetery, which was near where I was living, and I found his grave. And there was a lovely cross on it with the inscription: "Homer Dodge Martin, born Albany 1836, died Saint Paul 1897, landscape painter, erected by friends who loved his pictures."

Well, that piqued my interest, and then I found out that his masterpiece, *View of the Seine: Harp of the Winds*, was also painted in Saint Paul, in a studio not far from the state capitol. Memories of his sojourn in France, where he lived for several years in the 1880s. He had shared a studio in Europe with Whistler at one time and also one with Winslow Homer in New York City. So he was a very important artist in many ways, part Hudson River School, part Barbizon, with touches of Impressionism.

But, anyway, he came to Saint Paul in his last years, in 1893 I believe, because he was going blind and had a son living here. He thought the clean air might help his eyesight. In fact, he was almost blind when he painted *View of the Seine*, which is now in the

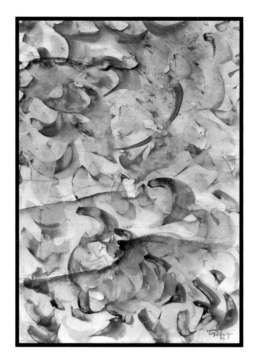

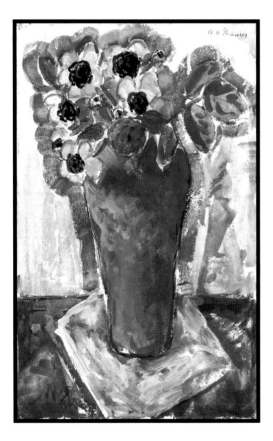

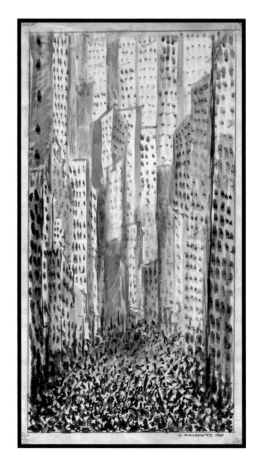

Mark Tobey
Untitled

Alfred H. Maurer
Still Life with Vase of Flowers

Abraham Walkowitz
Cityscape: New York Improvisation

Metropolitan Museum. And every time I go to New York, when I've gone through the Met's American collection, it's hanging. They show it constantly.

Both of my Martins, in fact, were purchased during visits to New York from the Kennedy Galleries. The first one I bought, which is called *Point Pleasant, Lake Ontario*, is from the artist's later period, after he had been in France and came back with some of the Impressionist influence. The second, which I found a year or two later, is called *Hudson River Landscape*, and that was from his earlier years and is more typical of his Hudson River paintings.

A sizeable portion of your collection consists of drawings. Did you decide to focus on drawings as a collecting strategy or was this something that merely evolved over the years?

Well, I think it was partly because of the cost. Drawings were less expensive than paintings, of course, and therefore more affordable. But I've come to like drawings, their immediacy, their intimacy of expression. Many years ago, I bought four or five Old Master drawings at the old Rockman Galleries on Third Avenue in New York City. He put his drawings in boxes, and he'd have the three-dollar box, the five-dollar box, the ten-dollar box, the fifteen-dollar box, and so on. I never got beyond the ten- or fifteen-dollar box, because that was my limit then, but I was able to buy some very respectable pieces. I often wonder now what was in the fifty-dollar box. Bouchers, maybe, or Fragonards. I only wish that I'd have bought more because there were some great opportunities.

You began collecting modernist American art in the 1950s. Did you also collect the Abstract Expressionists?

No, I didn't get too much involved in that. I have just a smattering of it, mostly by such local artists as Cameron Booth.

But you do have an abstraction by Mark Tobey in your collection.

Oh, yes, the Tobey monotype. It's untitled; small, maybe six by nine inches; and very calligraphic. I'm very fond of it. I see a bird at the bottom center. Nobody else can, but I see a bird very plainly. I'm sure it was accidental. It was one of those monotypes he did that he'd rework later with a brush, redefining some of the areas. It's very delicate and beautifully colored with lovely pinks and blacks. Tobey, as you know, was more recognized in Europe than he was in America, but he's the only American since Whistler who had a one-man exhibition at the Louvre in Paris. He lived his last years in Switzerland and died there, but he grew up in the Midwest and also spent many years in Seattle, where he was associated with the painters Morris Graves and Ken Callahan.

You also own a landscape sketch by Marsden Hartley.

Yes, I bought it from the Babcock Galleries and Carmine Dalesio. And that was one he had to do a little talking on, because at that time I wasn't particularly interested in drawings. I just thought it had to be hand-painted oil pictures. So foolish, because I probably could have built a wonderful drawing collection then for very little. Well, finally I came to my senses, and now I'm extremely glad I did. My drawing is from Hartley's Dogtown series, which were all done in Gloucester, Massachusetts, in 1931. He did several versions of the subject, in painting, pen and ink, and so on. I think the University Gallery here also has an oil painting on this theme.

Your collection includes an excellent example of one of Abraham Walkowitz's famous "improvisations" of New York City street life. Would you tell me something about this work and why you acquired it?

That was purchased from Virginia Zabriskie at the Zabriskie Gallery.

Walkowitz was a well-known modernist painter who did many of his drawings right on the street. I'm told that he'd actually just give them to people as they walked by. Apparently he did it more for the joy of it rather than the profit. But the watercolor I have he kept for himself, and it was in his estate when he died. I like the silvery quality about it and the rushing energy of the crowds as they stream through the narrow canyons of New York.

You have an important still life by Alfred Maurer as well.

Yes, a gouache I bought from the Babcock Galleries. I was there one day in the late '50s talking to Carmine and asked if he had any works by Maurer. He pulled this out and said it just had come in on consignment from a lady in New York, but didn't have a price on it yet. So he offered to call her and find out. Then when I went back the next day, he said, "Well, she's out of town; she's up in Maine or someplace for the summer. But when she gets back I'll talk to her. So would you like to make an offer?" "Well," I said, "I'll pay a hundred dollars for it." So when she came back in the fall, he wrote me to say she'd accepted my price, which made it a real find. In any event, it's a very interesting piece and quite typical of his later style. He was very academic in his early career and, in fact, worked for his father, who was a printmaker for Currier & Ives. But then he went to Paris, where he became friends with the Steins, and was exposed to the Fauves and the Cubists. By 1907, he had changed his style radically and was painting with vibrant colors and simple, distorted forms. Like most American artists living abroad, he returned to the U.S. when World War I broke out, but never achieved acceptance into Stieglitz's modernist circle. And in the end, he died tragically, taking his own life, because he just didn't get any recognition. But his art is very appreciated now and highly collectible.

You also own an unusual watercolor by Ivan Albright.

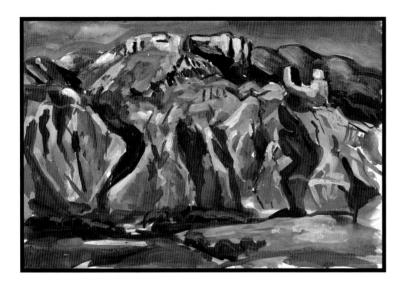

Ivan Le Lorraine Albright
The Tetons (Near Jackson Hole, Wyoming)

Edward Hopper
Double House, Gloucester

John Marin
Stonington Harbor, Deer Isle, Maine

Yes, the Albright landscape. So atypical of him, really. "Ivan Le Lorraine," I guess you should call Albright. His father was an artist, too, who was apparently very intrigued with the work of Claude Lorraine. Hence, the name. But anyway, the watercolor was so unlike Albright's tight, detailed realism, I wondered about its authenticity. So I sent a photo of it to Albright at his ranch out West, and he wrote back to say, yes, he'd done it in Jackson Hole, Wyoming, where he lived. I suppose he just got tired of doing those painstakingly drawn paintings of his and did it as relaxation.

One of my favorite works from your collection is the Edward Hopper drawing Double House, Gloucester. *How did you obtain it?*

Yes, the Hopper, one of my better acquisitions. A grand drawing, which I gave to the Art Institute several years ago in memory of my parents. I bought it in the 1950s in New York at the Rehn Gallery. I was there one summer and saw three or four of Hopper's drawings. None of them interested me much. But when I went back a few months later, I walked into John Clancy's office at the rear of the gallery and saw *Double House, Gloucester* hanging over the desk. And I got very excited and tried to calm myself. I said, "John, what about this *Double House*? What is the price of that?" And he replied, "The same price as the one you saw last summer." Well, I didn't hesitate and bought it on the spot. To me, there's a dignity and melancholy and almost starkness to the Hopper that I also sense in my Dale Nichols painting, which is extremely linear, too, and very American in subject matter.

Another important piece in your collection is a seascape by John Marin entitled Deer Isle, Maine. *Tell me about that.*

That was one of my big accessions, I think, one of the significant ones. It's one of his familiar subjects, up on the coast of Maine, where he did a lot of his painting. I bought it in the 1950s at the Downtown Gallery in New York from his son, John Marin, Jr. Initially, I'd been at the gallery looking at drawings, feeling I couldn't afford a Marin watercolor. Two weeks later I went back and they had a Christmas show up, and the *Deer Isle* watercolor was there and it was well priced. So I talked to John about it and he said, "Well, it may cost a little more than a drawing, but as you know, that was my father's major medium." So, I had it sent out and debated about it for quite a long time. In fact, I was almost about to return it when Antoinette Kraushaar came to Minneapolis to speak at the Walker Art Center. I took her around to show her the sights of the city and told her of my dilemma. And she said, "Since Marin is a great American painter, it would lift the caliber of your collection if it included a Marin watercolor." So that clinched it. I kept it and I'm very pleased I did.

You do have quite a number of watercolors in your collection. Are you particularly interested in this medium?

I wasn't originally, but over the years I've come to appreciate watercolors, like drawings, as being a more spontaneous expression of the artist's approach to a subject. So there's a freshness, an appealing quality to them. And if I could do it over again, I would certainly go even more in that direction.

What criteria do you use in collecting art?

That's hard for me to say, why I like a picture. I'm not very good at analyzing the technical aspects of painting. But I guess there are some innate things I respond to and just like. Those are the purchases that come about by happenstance. And then, some of them are bought because I want to fill in gaps. Actually, it seems that I have three criteria when buying a work of art. First of all, it needs to be an artist I'm looking for. Second, it has to be something I like. And third, something I can afford. And usually I'm able to meet those

requirements with most of the pieces I purchase.

Your collection numbers over three hundred works today. Why do you continue to collect?

Well, I suppose you never get over the collecting bug. It's a disease that's incurable and definitely long-term.

You've been very generous over the years in lending and giving your works to the community. Is that part of your collecting philosophy?

Well, I've been happy to do so. I guess it sort of salves your ego a little bit to know that you've got things people want to borrow and look at. But more importantly, it's been interesting because pictures take on a different look when they're hung in a different setting. I live with them here, day after day, and finally you hardly even see them. But when you pull them out of the house and put them in a new place, they take on a new life and excite me all over again. It's the same with donating pieces to museums. You know where they'll be for all time to come, and since you can always go see them, it's as if they're still yours in a way.

And what advice would you give someone who was just beginning to collect art?

I think the first thing they ought to do is try to find out what they like in art. And the way to do that is to look at it as often as possible. Make frequent visits to the art galleries and museums, particularly museums, because anything you spend your time looking at there has already met the test of time and the art connoisseur. And then, you should read a great deal and get to know other collectors and art dealers and artists, if you can, because you learn a lot from them, too. And, of course, buy the things that appeal to you and that you can afford. Because in the end, you should only have pieces that you really like and that give you pleasure whenever you look at them.

Catalogue of the Exhibition

Ivan Le Lorraine Albright
(1897–1983)
The Tetons (Near Jackson Hole, Wyoming), 1948

Gouache and watercolor on paper
12 x 17⅞ inches
Signed lower right: *Ivan Le Lorraine Albright*
RLH 196

PROVENANCE
[Findlay Galleries, Chicago]
Richard Lewis Hillstrom, Saint Paul,
1964

EXHIBITIONS
Lutheran Brotherhood, Minneapolis,
1975
Saint Olaf College, Northfield,
Minnesota, 1976
College of Saint Catherine, Saint Paul,
1986
Gustavus Adolphus College, Saint Peter,
Minnesota, 1987

The artist can express inner moods, subtle-unconsciousness—mysterious urgings and they are the fruits of the imagination—of unreality. To believe in the unreality of things as well as the reality is essential.
—Ivan Albright

An enigmatic figure among twentieth-century American artists, Ivan Albright concentrated throughout his career on themes that emphasized the fleeting nature of human existence. Noted for his figural and still-life paintings, Albright used exaggerated surface detail and strongly contrasted lights and darks to evoke an aura of age and decay. His meticulous analysis of form and texture required painstaking attention, often restricting his progress on a painting to no more than one square inch per day. Perhaps to escape the regimen of this intricate technique, Albright traveled extensively, leaving his studio for extended periods to concentrate on less demanding media.

The Tetons, a watercolor and gouache drawing of 1948, was completed during one such sojourn to the western United States. Beginning that year and continuing intermittently until 1963, Albright spent his summers at the Three Spear Ranch in Dubois, Wyoming, where he produced numerous landscape sketches and watercolors. According to the artist, *The Tetons* was painted near Jackson Hole, Wyoming, fifty miles west of Dubois. Although quite different in style from his oil paintings, his watercolors share certain characteristics, including melancholy themes, bleak yet beautiful settings, and dramatic contrasts of light and shadow to indicate form. Albright's watercolors were conceived as independent works of art, important exceptions to his view that drawings are merely studies for paintings.

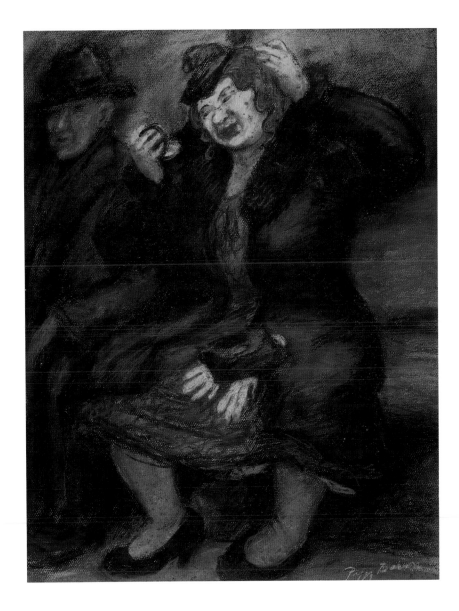

Peggy Bacon
(1895–1987)
Finishing Touches, about 1937

Verso: Figure study
Pastel on pale gray charcoal paper
22¼ x 17¼ inches
Signed lower right: *Peggy Bacon*
RLH 292

PROVENANCE
[Parke-Bernet Galleries, New York]
[Kraushaar Galleries, New York]
Richard Lewis Hillstrom, Saint Paul,
1970

EXHIBITIONS
Lutheran Brotherhood, Minneapolis,
1975
University Gallery, University of
Minnesota, Minneapolis, 1976, 1977

Saint Olaf College, Northfield,
Minnesota, 1976
Minnesota Museum of Art, Saint Paul,
1981

REFERENCES
Mariea Caudill, *The American Scene:
Urban and Rural Regionalists of the
'30s and '40s* (Minneapolis: University
of Minnesota Gallery, 1976), no. 60.
Mari Ann Barta, *Images of Women in
American Graphic Arts, 1900–1930*
(Minneapolis: University of Minnesota
Gallery, 1977).
Thomas S. Holman, *American Style:
Early Modernist Works in Minnesota
Collections* (Saint Paul: Minnesota
Museum of Art, 1981), no. 3.

Finishing Touches epitomizes Peggy
Bacon's satirical caricatures from the
1930s. The pastel drawing, probably
completed in early 1937, is from a
series known as "Manhattan Genre,"
which chronicled the foibles of ordi-
nary people living on the Lower East
Side of New York City. The scene
here is set on the subway, where a
heavy, middle-aged woman primps in
the mirror of her compact. Fully
absorbed in her task, she is oblivious
to her public surroundings. The view-
point is that of an unseen fellow pas-
senger on the train, and the portrayal
is both unflattering and unsympa-
thetic. Typical of Bacon's illustrative
style of drawing, the ironic interpreta-
tion of human vanity comments on
society as a whole, a primary goal of
much of the artist's early work.

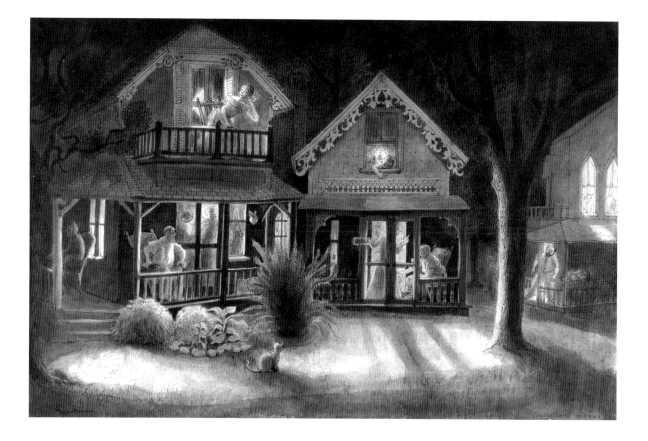

Peggy Bacon
(1895–1987)
Quarrelsome Gnomes, 1952

Black and brown ink, watercolor and
ink wash on paper
12 x 18 inches
Signed lower left: *Peggy Bacon*
Inscribed lower right: *Quarrelsome
Gnomes*
RLH 190

PROVENANCE
[Kraushaar Galleries, New York]
Richard Lewis Hillstrom, Saint Paul,
1963

EXHIBITIONS
Saint Olaf College, Northfield,
Minnesota, 1976

During the 1950s, Bacon tempered
the satire that had dominated her
earlier work and began to experiment
with the formal problems of color and
composition. Using various combina-
tions of watercolor, gouache, and ink,
Bacon created elaborately detailed
drawings that allowed for both com-
positional and thematic exploration.
Noted more for their fanciful themes
than for any stylistic innovations,
these drawings convey the wit and

charm that became synonymous with
much of Bacon's later art.

Quarrelsome Gnomes, an ink-and-
wash drawing of 1952, typifies this
work. In a 1963 letter to Richard L.
Hillstrom, Bacon described the draw-
ing's setting and content in detail.

*Box 25
Cape Porpoise, Maine
April 29, 1963*

Dear Reverend Hillstrom,

*Antoinette Kraushaar has asked me to
write you, giving the date of the pen-
and-wash picture of mine which you
bought, and also some particulars
about it. The date was 1952. In that
year and the following, and again in
1956 and 1957, I did a series of wash
drawings and gouaches of a fantastic
neighborhood on Martha's Vineyard,
known to some as "Cottage City," actu-
ally an old summer camping site of
Methodist ministers and their families.
About the time of the Civil War or pos-
sibly earlier, they commenced to con-
gregate and pitch their tents in an
area of many acres near Oak Bluffs,
returning year after year. Later, each
family having somehow acquired the
tiny parcel of land on which they had
pitched their tent, they erected tiny
houses, incredibly narrow (because of
the shape of the plot), as close together*

*as possible, and all of "gingerbread."
The trees have grown tall, there are no
roads or scarcely any, only paths, grass
plots, flowerbeds; and a great quiet pre-
vails (unlike the scene in my fantasy).
The cottages are painted in the most
riotous and playful colors, in a maze
of woodland walks, presenting a scene
of childish charm. In the center of this
crazy fairyland there is a great out-
door bandstand in a huge circle of
lawn, where they hold band concerts
and give sermons and there is a taber-
nacle nearby. The same families, the
descendants, return each summer, and
on the night of the full moon in
August they hold a ceremonial or festi-
val, when they unpack and hang all
over their cottages, from balconies and
windows, and all up and down every
walk and circle (there are innumer-
able tiny circles surrounding gardens,
shared by perhaps seven or eight cot-
tages) all the accumulated colored
paper lanterns that have come down
to them for a hundred years. These are
lit and make such a display that peo-
ple come from all over the island to see
it and to hear the concert. Most of the
cottages are kept up, repainted in gay,
uninhibited hues, everything is very
neat, dainty and idiotic.*

*Sincerely,
Peggy Bacon*

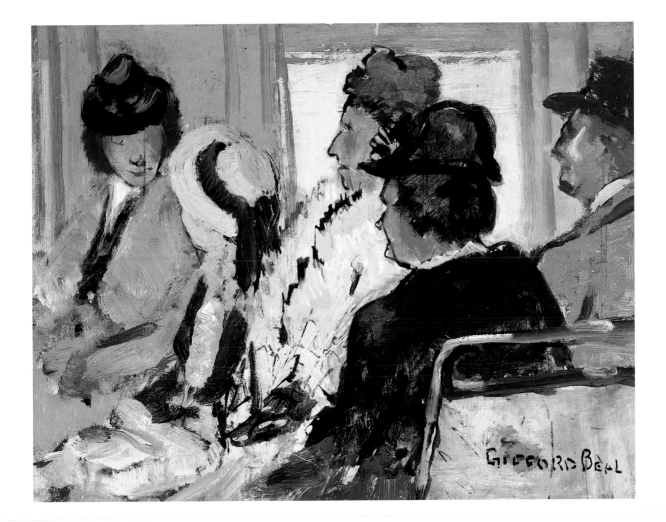

Gifford Reynolds Beal
(1879-1956)
Fifth Avenue Bus #2, 1947

Verso: Café scene
Oil on wood panel
9 x 12 inches
Signed lower right: *Gifford Beal*
Inscribed verso (removed): *Fifth Ave.*
Bus/Gifford Beal/19 Atlantic Ave.
RLH 205

PROVENANCE
Estate of the artist, 1956
[Kraushaar Galleries, New York]
Richard Lewis Hillstrom, Saint Paul,
1965

EXHIBITIONS
American Academy of Arts and Letters,
New York, 1956
Kraushaar Galleries, New York, 1965
The Minneapolis Institute of Arts,
Minneapolis, 1969
Birger Sandzén Memorial Gallery,
Lindsborg, Kansas, 1972

Gifford Beal's painting style emerged
under the tutelage of William Merritt
Chase, who during the 1890s had
become an important proponent of
American Impressionism. Like many
American Impressionists, Beal re-
jected the intense color and diffuse
form of his French counterparts, pre-
ferring instead the more naturalistic
depiction of objects.

A late example of Beal's oeuvre,
Fifth Avenue Bus #2 has the subdued
palette and painterliness of his mature
style. As seen here, Beal concentrated
on scenes of New York, where he
was born and spent much of his life.
This picture, set on a public bus,
shows a small group of passengers
involved in casual activities. Beal was
fascinated by the energy of urban life
and recorded contemporary events in
his native city with a generally posi-
tive outlook. On the back of the paint-
ing, Beal created a second composi-
tion that provides another glimpse of
city life. There, the setting is a New
York City café, where diners noncha-
lantly read the menu while a waiter
stands patiently nearby. Unsigned and
less finished than the reverse side, the
café painting may have been a prelim-
inary study for a larger composition.

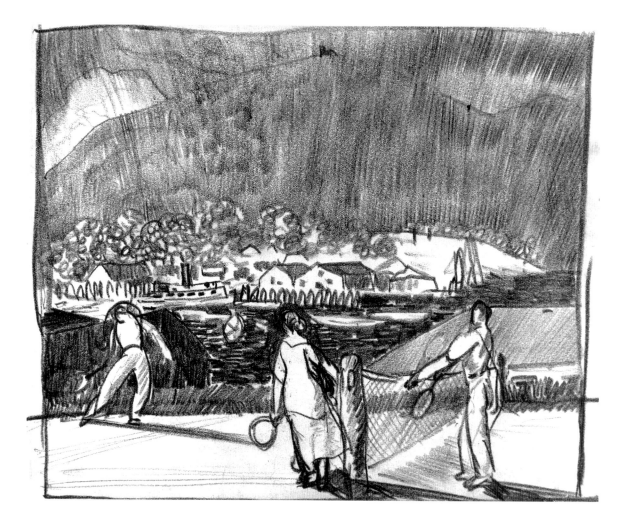

George Bellows
(1882-1925)
Tennis Match (Camden, Maine), 1916

Verso: Figure study
Conté crayon on paper
8 x 10⅞ inches
Signed lower left verso: *Geo. Bellows/ E. S. B.*
Inscribed verso: *Tennis in Camden, Maine*
RLH 114

PROVENANCE
Estate of the artist, 1925
[H. V. Allison & Company, New York]
Richard Lewis Hillstrom, Saint Paul, 1958

EXHIBITIONS
Lutheran Brotherhood, Minneapolis, 1975
Saint Olaf College, Northfield, Minnesota, 1976
University Gallery, University of Minnesota, Minneapolis, 1977 (exhibition traveled to Stillwater Public Library, Stillwater, Minnesota; Saint Olaf College, Northfield, Minnesota; Princeton Public Library, Princeton, Minnesota; Red Wing Public Library, Red Wing, Minnesota; South Saint Paul Public Library, South Saint Paul, Minnesota; Marshall Public Library, Marshall, Minnesota)

REFERENCES
Mari Ann Barta, *Images of Women in American Graphic Arts, 1900-1930* (Minneapolis: University of Minnesota Gallery, 1977).

With his wife, Emma, and friend and fellow artist Leon Kroll, George Bellows spent the summer of 1916 in the small coastal community of Camden, Maine. Bellows's conté crayon *Tennis Match* is one of many sketches made during that trip. The lively drawing depicts Bellows, Emma, and Kroll in the midst of a tennis match, one of their favorite summer pastimes. Set against a landscape that rises like a scenic backdrop to the game, the players appear like actors on a stage, complete with dramatic lighting. An avid sportsman, Bellows frequently used athletics as subjects for his work. Tennis, in fact, was the theme of several other paintings and drawings and two lithographs.

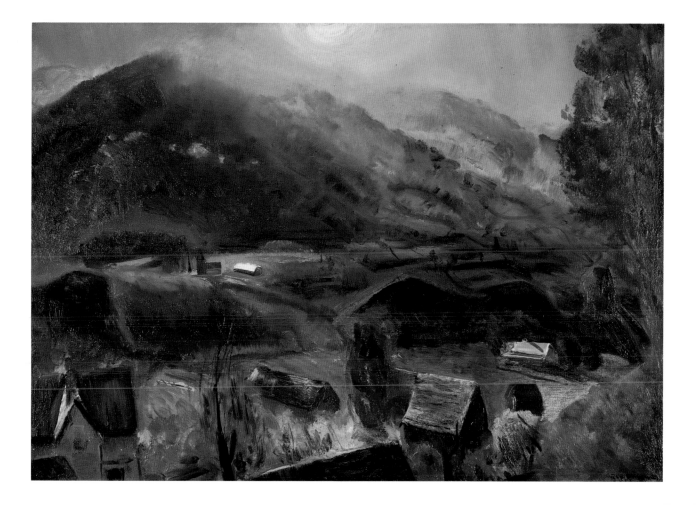

George Bellows
(1882–1925)
Sunset, Shady Valley, 1922

Oil on wood panel
16⅛ x 24 inches
Signed lower right: *Geo Bellows/E S B*
Signed and inscribed, verso: *Sunset Shady Valley/Geo Bellows*
RLH 436

PROVENANCE
Estate of the artist, 1925
Emma Story Bellows (the artist's wife), 1925
Estate of Emma Story Bellows, 1951
Gordon K. Allison
[H. V. Allison & Company, New York]
Richard Lewis Hillstrom, Saint Paul, 1978

EXHIBITIONS
College of Saint Catherine, Saint Paul, 1986
Gustavus Adolphus College, Saint Peter, Minnesota, 1987

A leading twentieth-century realist, George Bellows excelled as both a painter and a printmaker, whose vigorous style and direct approach revealed the mastery of his technique. Closely associated with Robert Henri and the realists known as The Eight, Bellows concentrated on themes of American life throughout his career. Chief among these were exuberant urban scenes, quiet portraits of his family and friends, and rural landscapes.

Part of a group of about twenty landscape paintings, *Sunset, Shady Valley* was completed by Bellows in the fall of 1922 near his home in Woodstock, New York. At the urging of his close friend Eugene Speicher, Bellows spent summers in the Catskill Mountains beginning in 1920 and built a house and studio there in 1922. That autumn, along with fellow artists Speicher and Charles Rosen, Bellows set out on daily excursions into the areas surrounding his Woodstock home. *Sunset, Shady Valley*, with its high vantage point, vivid colors, and broad brushstrokes, was made on one of these outings and features several farmsteads and mist-shrouded mountains. In the distance, the sun sets with an intense yellow glow. Alternating areas of light and dark colors help give the lush landscape its rolling, undulating appearance. This movement adds to the vibrant quality of the image, as does Bellows's careful rendering of light and atmosphere, which gives a sense of otherworldliness to the commonplace scene. Bellows's paintings like this possess an evocative, visionary power that recalls the mystical landscapes of the Spanish master El Greco, whose work Bellows greatly admired.

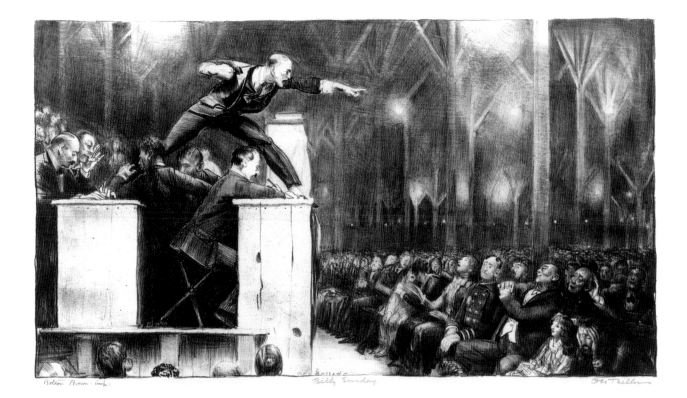

George Bellows
(1882–1925)
Billy Sunday, 1923

Lithograph on wove paper, edition
of 60
9 x 16⅛ inches (image)
15⅞ x 21⅞ inches (sheet)
Signed on stone, lower center: *Geo
Bellows*
Signed beneath image, lower right: *Geo
Bellows*; lower left: *Bolton Brown—imp*
Inscribed beneath image, lower center:
Billy Sunday
RLH 246

PROVENANCE
[H. V. Allison & Company, New York]
Richard Lewis Hillstrom, Saint Paul,
1967

EXHIBITIONS
Saint Olaf College, Northfield,
Minnesota, 1976
Minnesota Museum of Art, Saint Paul,
1982 (exhibition traveled to Elvehjem
Museum of Art, Madison, Wisconsin;
Terra Museum, Evanston, Ilinois)
Gustavus Adolphus College, Saint Peter,
Minnesota, 1987

REFERENCES
Emma S. Bellows, *George W. Bellows:
His Lithographs* (New York: Alfred A.
Knopf, 1927), no. 111.
Lauris Mason, *The Lithographs of
George Bellows: A Catalogue Raisonné*
(Millwood, N.Y.: Kraus-Thomson
Organization, 1977), no. 143.
George Bellows: Lithographs (Saint Paul:
Minnesota Museum of Art, 1982), no. 40.

For George Bellows, lithography was
a natural outgrowth of his activities as
an illustrator. A highly skilled drafts-
man, Bellows had supplemented his
early income by illustrating various
American publications. In 1915, the
editor of New York's *Metropolitan
Magazine* asked him to cover the
Philadelphia crusade of the charis-
matic evangelist William "Billy"
Sunday. Two of Bellows's drawings
appeared in the magazine that May
along with John Reed's story of the
event. Bellows's lithographs *The
Sawdust Trail* (1917) and *Billy*
Sunday (1923) replicate those two
drawings. In *Billy Sunday*, Bellows
depicted the evangelist in a moment
of religious fervor, aggressively engag-
ing the crowd. Bellows disliked
Sunday as he made clear in a 1917
interview: "I like to paint Billy
Sunday, not because I like him, but
because I want to show the world
what I do think of him. Do you know,
I believe Billy Sunday is the worst
thing that ever happened to America?
He is death to imagination, to spiritu-
ality, to art. Billy Sunday is
Prussianism personified. His whole
purpose is to force authority against
beauty. He is against freedom, he
wants a religious autocracy, he is such
a reactionary that he makes me an
anarchist."[1] An important example of
Bellows's critical treatment of reli-
gious dogma, the print *Billy Sunday*
has become one of the artist's best-
known lithographs.

[1] "The Big Idea: George Bellows Talks about
Patriotism for Beauty," *Touchstone* 1 (July
1917): 270.

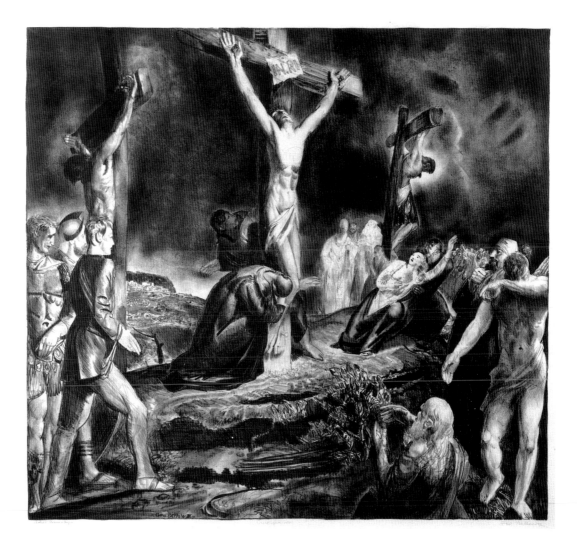

George Bellows

(1882-1925)
Crucifixion of Christ, 1923

Lithograph on laid paper, edition of 65
18¾ x 20⅝ inches (image)
21⅛ x 26¼ inches (sheet)
Signed on stone, lower left: *Geo Bellows*
Signed beneath image, lower right: *Geo Bellows*; lower left: *Bolton Brown—imp*
RLH 239

PROVENANCE

[H. V. Allison & Company, New York]
Richard Lewis Hillstrom, Saint Paul, 1967

EXHIBITIONS

Luther College, Decorah, Iowa, 1968
University Gallery, University of Minnesota, Minneapolis, 1973
Lutheran Brotherhood, Minneapolis, 1975
Saint Olaf College, Northfield, Minnesota, 1976
Minnesota Museum of Art, Saint Paul, 1982 (exhibition traveled to Elvehjem Museum of Art, Madison, Wisconsin; Terra Museum, Evanston, Illinois)
College of Saint Catherine, Saint Paul, 1986
Gustavus Adolphus College, Saint Peter, Minnesota, 1987

REFERENCES

Emma S. Bellows, *George W. Bellows: His Lithographs* (New York: Alfred A. Knopf, 1927), no. 97.
Donna Isaac, *New York Artists of the 1920's* (Minneapolis: University of Minnesota Gallery, 1973).
Lauris Mason, *The Lithographs of George Bellows: A Catalogue Raisonné* (Millwood, N.Y.: Kraus-Thomson Organization, 1977), no. 146.
George Bellows: Lithographs (Saint Paul: Minnesota Museum of Art, 1982), no. 41.

Though religious and historical themes are not common among his works, George Bellows completed three versions of the *Crucifixion of Christ*. According to his wife, Emma, he first created a drawing of the subject, then a lithograph. The drawing appeared as an illustration to "I Saw Him Crucified," a short story by Arthur Conan Doyle, which was published in William Randolph Hearst's *International Magazine* in 1922. The lithograph, based directly on the drawing, depicts the final moment of Christ's death. Dominated by a dark, threatening sky, the composition features strangely elongated figures and a surreal quality of light. At the left, three soldiers, one of whom is the narrator in Doyle's story, witness the scene. In the fall of 1923, Bellows made an important oil painting of the same subject.

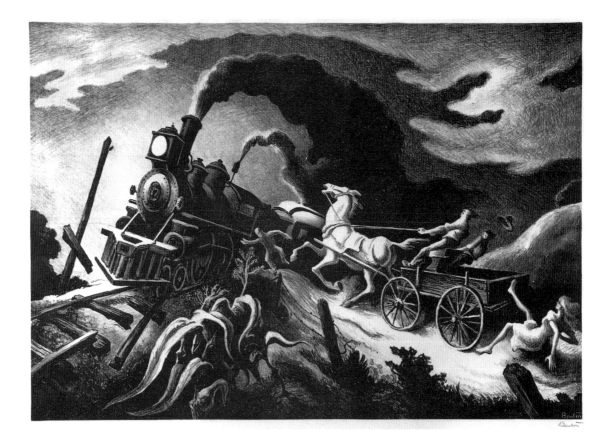

Thomas Hart Benton
(1889–1975)
Wreck of the Ol' 97, 1944

Lithograph on wove paper, edition
of 250
10⅜ x 14⅞ inches (image)
12⅞ x 17 inches (sheet)
Signed on stone, lower right: *Benton*
Signed beneath image, lower right:
Benton
Gift of Richard L. Hillstrom in memory
of his parents, Alma and Martin
Hillstrom, The Minneapolis Institute of
Arts P.85.62

PROVENANCE
[Associated American Artists Gallery,
Chicago]
Richard Lewis Hillstrom, Saint Paul,
1945
The Minneapolis Institute of Arts, 1985

EXHIBITIONS
The Minneapolis Institute of Arts,
Minneapolis, 1971
Lutheran Brotherhood, Minneapolis,
1975
University Gallery, University of
Minnesota, Minneapolis, 1976 (exhibi-
tion traveled to Carleton College,

Northfield, Minnesota; Rochester Art
Center, Rochester, Minnesota; Noble
County Art Center, Worthington,
Minnesota; Willmar Community
College, Willmar, Minnesota; Owatonna
Art Center, Owatonna, Minnesota;
Winona Art Center, Winona, Minnesota;
Metropolitan Community College,
Minneapolis; Cedar Rapids Art Center,
Cedar Rapids, Iowa)
University Gallery, University of
Minnesota, Minneapolis, 1981

REFERENCES
Creekmore Fath, *The Lithographs of
Thomas Hart Benton* (Austin:
University of Texas Press, 1969), no. 63.
Mariea Caudill, *The American Scene:
Urban and Rural Regionalists of the
'30s and '40s* (Minneapolis: University
of Minnesota Gallery, 1976), no. 6.
*Contact: American Art and Culture,
1919–1939* (Minneapolis: University of
Minnesota Gallery, 1981).

One of the leading regionalist painters
of the 1920s and 1930s, Thomas Hart
Benton believed that art should result
from the interaction between artists
and their physical environments
rather than from abstract ideas. As an
avowed realist, he renounced his

early interest in European mod-
ernism and instead concentrated on
American themes and popular folk-
lore. One of Benton's best-known litho-
graphs, *Wreck of the Ol' 97*, which
was based on one of his paintings,
recounts the destruction of Southern
Railroad's Train No. 97 at Stillhouse
trestle near Danville, Virginia, on
September 27, 1903. Widely known
from a song of the 1920s, the story
still remains part of America's folk-
lore. In a written supplement pub-
lished with the print, Benton
described the scene: "Goin' down
grade at ninety miles an hour, Ol' 97
hit a broken rail and hell busted loose.
This picture shows the moment just
before the bust. The song doesn't say
who saw the affair, but somebody
must have, and it could just as well
have been people like those in the
wagon. I put 'em in anyhow."[1] Drawn
in his characteristically exuberant
style, this memorable print is but one
of nearly one hundred lithographs
Benton completed during his career.

[1]Thomas Hart Benton, "Patron's
Supplement, No. 27," Associated
American Artists (1944).

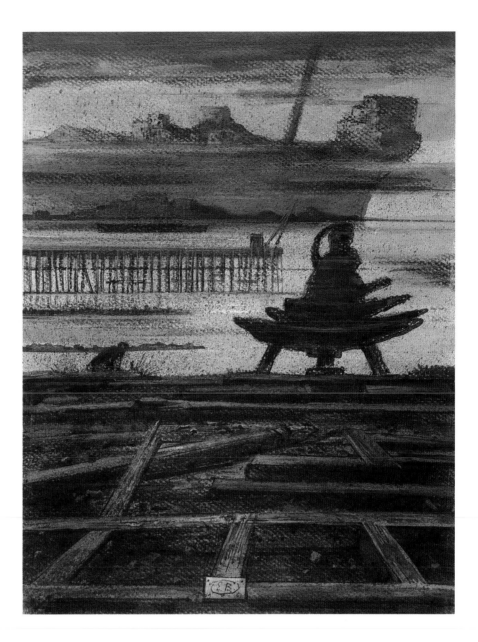

Eugene W. Berman
(1899-1972)
Notturno Partenopeo
(Neapolitan Nocturne), 1961

Watercolor and black ink on gray
charcoal paper
12⅞ x 9⅞ inches
Signed with initials and dated lower
center: *E. W. B./1961*
RLH 237

PROVENANCE
[Sears Vincent Price Gallery, Chicago]
Richard Lewis Hillstrom, Saint Paul,
1967

EXHIBITIONS
Frank Oehlschlaeger Galleries, Chicago,
1965

Luther College, Decorah, Iowa, 1968
Gustavus Adolphus College, Saint Peter,
Minnesota, 1969
Lutheran Brotherhood, Minneapolis,
1975
Saint Olaf College, Northfield,
Minnesota, 1976

Depicting a distant and imaginary
world, *Notturno Partenopeo*
(Neapolitan Nocturne) typifies the
graphic work of Eugene Berman.
Rich with nostalgia for a time and
place long lost, the watercolor also
reveals the romantic vision of the
artist. "The whole method of think-
ing, of building a picture, everything
that I admire and strive for," wrote
Berman, "derives from my admiration
of the Renaissance universal man, his

clarity in thinking, his proficiency in
many arts, his mastery of architec-
ture, perspective, etc., etc."[1] In the
spirit of Giovanni Piranesi and the
Venetian "view" painters, Berman
shows the magnificent architecture
of an ancient seaport, mindful to
convey its air of melancholy and iso-
lation. Intimate in scale and muted in
color, the exquisitely crafted drawing
imparts a mood of quiet contempla-
tion. A prolific and skilled draftsman,
Berman produced many hundreds
of drawings over his entire career,
often completing several versions
of a subject.

[1] Eugene Berman, *The Graphic Work of
Eugene Berman* (New York: Clarkson N.
Potter, 1971), p. x.

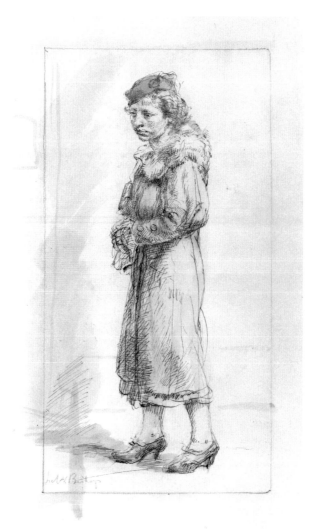

Isabel Bishop
(1902–88)
Woman Walking, about 1933

Black ink and wash on paper
12⅞ x 9 inches
Signed lower left: *Isabel Bishop*
RLH 151

PROVENANCE
[Midtown Galleries, New York]
Richard Lewis Hillstrom, Saint Paul,
1962

EXHIBITIONS
University Gallery, University of
Minnesota, Minneapolis, 1973, 1976
Lutheran Brotherhood, Minneapolis,
1975
Saint Olaf College, Northfield,
Minnesota, 1976
University Gallery, University of
Minnesota, Minneapolis, 1977 (exhibi-
tion traveled to Stillwater Public Library,
Stillwater, Minnesota; Saint Olaf College,
Northfield, Minnesota; Princeton Public
Library, Princeton, Minnesota; Red
Wing Public Library, Red Wing,
Minnesota; South Saint Paul Public
Library, South Saint Paul, Minnesota;
Marshall Public Library, Marshall,
Minnesota)

REFERENCES
Donna Isaac, *New York Artists of the
1920's* (Minneapolis: University of
Minnesota Gallery, 1973).
Mariea Caudill, *The American Scene:
Urban and Rural Regionalists of the
'30s and '40s* (Minneapolis: University
of Minnesota Gallery, 1976), no. 45.
Mari Ann Barta, *Images of Women in
American Graphic Arts, 1900–1930*
(Minneapolis: University of Minnesota
Gallery, 1977).

Throughout her long career, Isabel
Bishop chose the human figure as her
primary subject. From her early
schooling under Kenneth Hayes Miller
and Guy Pène du Bois at the Art
Students League through her long
association with fellow artists
Reginald Marsh and Raphael Soyer,
Bishop was fascinated by the every-
day activities of ordinary people. Her
preferred themes, for paintings as
well as graphics, consisted of urban
landscapes, especially of Union
Square in New York City, where she
found such typical subjects as office
workers, shoppers, and the unem-
ployed in their usual surroundings.
Her work, however, did not contain
social commentary, but focused
instead on the dynamic rhythms of
figures in motion.

One of thousands of figure stud-
ies completed during her career,
Woman Walking exemplifies
Bishop's interest in character types.
Quickly rendered in pen and ink from
the streets of New York, her sketch
was designed to capture the pose,
appearance, and mood of her sub-
ject—a young woman isolated from
her surroundings as if frozen in time.
Studies like this served as models and
sources of inspiration for many of
Bishop's paintings and prints.

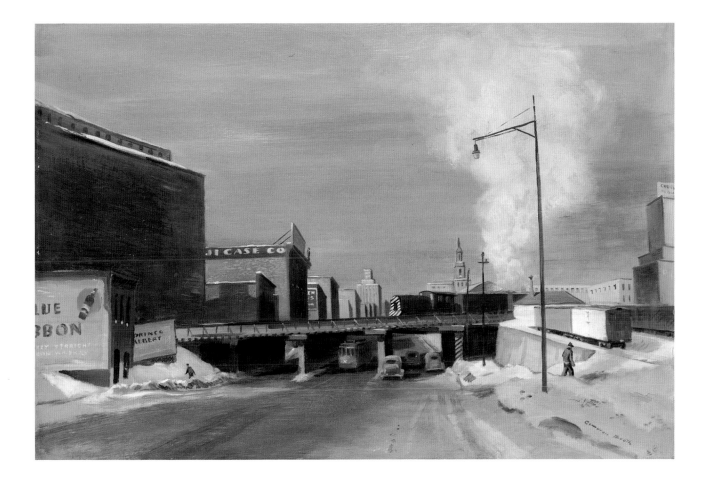

Cameron Booth

(1892–1980)
*Washington Avenue Viaduct
(Minneapolis)*, 1941

Verso: Unfinished landscape
Oil over egg emulsion on Masonite
panel
20 x 30 inches
Signed and dated, lower right: *Cameron
Booth 41*
Inscribed verso: *Washington Viaduct*
Gift of the Reverend Richard L. Hillstrom,
Minnesota Historical Society Collections

PROVENANCE
Acquired from the artist by Richard
Lewis Hillstrom, Saint Paul, 1971
Minnesota Historical Society, 1991

EXHIBITIONS
Minnesota State Fair, Saint Paul, 1942
The Minneapolis Institute of Arts,
Minneapolis, 1976
Lutheran Brotherhood, Minneapolis,
1983
College of Saint Catherine, Saint Paul,
1986

Gustavus Adolphus College, Saint Peter,
Minnesota, 1987

REFERENCES
The American Arts: A Celebration
(Minneapolis: The Minneapolis Institute
of Arts, 1976).

NOTE
The artist made the painting's frame
himself.

Born in Erie, Pennsylvania, in 1892,
Cameron Booth had a long association
with Minnesota, which began in his
childhood when his family settled in
Moorhead. From 1912 to 1917, Booth
received his first formal art education
under H. M. Walcott at the Art Institute
of Chicago. Following military
service in Europe and a brief stay in
Provincetown, Massachusetts, Booth
accepted a position at the Minneapolis
School of Art (now the Minneapolis
College of Art and Design), where he
taught from 1921 to 1929, and then at
the Art School of the Saint Paul Gallery,

which he headed until 1942.

From the early 1920s to the mid-
1940s, Booth concentrated on scenes
of urban and rural life in Minnesota.
As a realist and painter of local
themes, he was often labeled a region-
alist, a characterization he firmly
rejected because of his formalist train-
ing. *Washington Avenue Viaduct*, an
oil on panel of 1941, typifies much of
Booth's work from this period. The
painting, of a late winter streetscape
in the milling district of Minneapolis,
evokes a sense of quiet isolation. But
its principal subject is actually the
complex arrangement of geometric
structures that make up the city, and
this exploration of form always
remained the artist's primary con-
cern. An important work in Booth's
oeuvre, this painting hung in the
artist's studio for nearly thirty years.
Richard Hillstrom acquired it from
Booth with the understanding that
someday it would be given to the
Minnesota Historical Society.

Charles E. Burchfield
(1893–1967)
Young Elm, 1927

Carbon pencil on paper
13¾ x 19⅝ inches
Signed with initials, lower right: *CEB*
RLH 207

PROVENANCE
[Frank K. M. Rehn Gallery, New York]
Richard Lewis Hillstrom, Saint Paul,
1965

EXHIBITIONS
Frank K. M. Rehn Gallery, New York,
1964
Luther College, Decorah, Iowa, 1968
The Minneapolis Institute of Arts,
Minneapolis, 1969
University Gallery, University of
Minnesota, Minneapolis, 1974, 1984
Minnesota Museum of Art, Saint Paul,
1981

REFERENCES
Charles Burchfield Drawings (New
York: Frank K. M. Rehn Gallery, 1964),
no. 6.
Donna Isaac, *New York Artists of the
1920's* (Minneapolis: University of
Minnesota Gallery, 1973).
Thomas S. Holman, *American Style:
Early Modernist Works in Minnesota
Collections* (Saint Paul: Minnesota
Museum of Art, 1981), no. 9.

During the 1920s and 1930s, Charles
Burchfield portrayed both rural and
urban scenes with a greater realism
and austerity of style than he did in
his earlier, more fanciful images.
Young Elm, a carbon pencil drawing
of 1927, typifies these more somber
depictions of the East Coast country-
side. Completed while Burchfield was
living in Gardenville, a suburb of
Buffalo, New York, it pictures a small
farmstead with a water tower. The
windy, sunlit landscape includes a
solitary elm tree—a recurrent theme
of the artist's—that becomes the focal
point of the composition and, like his
lone figures, evokes a feeling of isola-
tion, even melancholy. The faint out-
line of a man walking along the road-
side underscores this sense of loneli-
ness. Meanwhile, as large cumulus
clouds pass overhead, a factory in the
distance belches smoke into the thin,
taut atmosphere. Quickly rendered on
site, drawings like this served as stud-
ies for Burchfield's more finished
works in watercolor and oil and were
rarely sold during his lifetime.

Charles E. Burchfield

(1893–1967)
Morning in the Alleghenies,
1954

Watercolor and conté crayon over
graphite on paper
12⅞ x 17½ inches
Signed with initials and dated, lower
left: *CEB/1954*
RLH 110

PROVENANCE
[Frank K. M. Rehn Galleries, New York]
Richard Lewis Hillstrom, Saint Paul,
1957

EXHIBITIONS
Walker Art Center, Minneapolis, 1957
Saint Paul Gallery of Art, Saint Paul, 1958
The Minneapolis Institute of Arts,
Minneapolis, 1970
Lutheran Brotherhood, Minneapolis,
1975
Saint Olaf College, Northfield,
Minnesota, 1976
College of Saint Catherine, Saint Paul,
1986

Gustavus Adolphus College, Saint Peter,
Minnesota, 1987
Minnesota Museum of Art, Saint Paul,
1989

REFERENCES
Collector's Club Exhibition
(Minneapolis: Center Arts Council,
1957), no. 23.

*It is the romantic side of the real
world that I try to portray. . . . My
things are poems (I hope).*
—Charles Burchfield

Best known for his evocative and mystical watercolors, Charles Burchfield used his deep love of the natural world as artistic inspiration throughout his life. During the later years of his career, he abandoned the austere realism he had practiced during the 1920s and 1930s and returned to the fanciful landscapes that had characterized his early period. In these intensely personal works, he sought to recapture his childhood fantasies of nature and

imbued them with a symbolic poetry uniquely his own.

In *Morning in the Alleghenies*, Burchfield demonstrated nature's enchanting power by depicting a serene vista of the Allegheny Mountains in western Pennsylvania. With a limited palette of greens, blues, and yellows, he distilled the sunlit landscape into interwoven, curvilinear patterns to represent the sounds and sensations of the isolated woodlands. Here, the utility poles and large pine trees seem alive with energy, an effect Burchfield achieved by surrounding them with a series of short, staccato lines. The mist-covered mountains in the distance act as a visual backdrop, constantly forcing the viewer's attention toward the house, road, and rocks of the foreground. Though the drawing was undoubtedly made from direct observation, Burchfield probably added the watercolors after returning to his studio, as several color notations in the finished composition suggest.

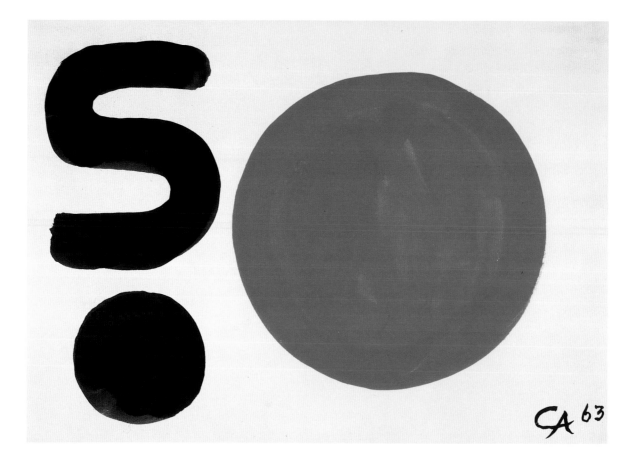

Alexander Calder

(1898–1976)
S for Sun, 1963

Gouache on paper
9¾ x 13⅞ inches
Signed with initials and dated, lower
right: *CA 63*
RLH 240

PROVENANCE
[James Goodman Gallery, Buffalo,
New York]
[Dayton's Gallery 12, Minneapolis]
Richard Lewis Hillstrom, Saint Paul,
1968

EXHIBITIONS
Dayton's Gallery 12, Minneapolis, 1968
Luther College, Decorah, Iowa, 1968
Gustavus Adolphus College, Saint Peter,
Minnesota, 1969
The Minneapolis Institute of Arts,
Minneapolis, 1970
Lutheran Brotherhood, Minneapolis,
1975
Saint Olaf College, Northfield,
Minnesota, 1976

Although best known as the inventor
of the mobile and the stabile,
Alexander Calder was also an accom-
plished painter, draftsman, and print-
maker. During the 1960s and early
1970s, he executed a series of highly
decorative gouaches that stylistically
recalled several tapestries he had
designed earlier in his career. Com-
posed of brilliantly colored abstract
and figurative forms, many of these
gouaches were untitled, but some had
such lighthearted names as *Spiral with
Propeller*, *The Lion and the Elephant*,
and *Rising Sun, Sickle Moon*. Calder

declared, however, that the underlying
concept for all his abstractions was the
organization of the universe, and cos-
mic imagery, in fact, remains one of his
recurrent themes.

S for Sun, a gouache drawing
from 1963, reflects Calder's lifelong
interest in whimsical subjects and
abstract designs. Here, he arranged
three simple geometric shapes—a
large red disk, a small black disk, and
a black *S*—on white paper. Though
no apparent connection between the
three elements exists, Calder's playful
title does suggest a conceptual rela-
tionship. It implies that the *S* (as the
first letter in the word "sun") symbol-
izes the sun with the same authority
as does a red disk. Thus, Calder clev-
erly posits that all artistic forms—
whether representational or abstract—
are merely intangible concepts.

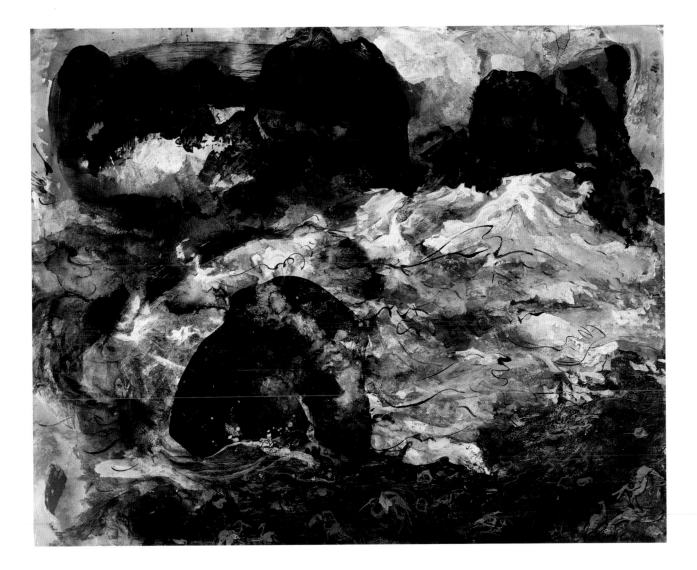

Kenneth L. Callahan
(1905–86)
Rocks and Surf, 1967

Tempera on paper, coated with wax,
mounted on particleboard
28⅞ x 23 inches
Signed lower right: *Kenneth Callahan*
RLH 248

PROVENANCE
[Kraushaar Galleries, New York]
Richard Lewis Hillstrom, Saint Paul,
1967

EXHIBITIONS
Minnesota Museum of Art, Saint Paul,
1989

*It is nature, with its unlimited var-
ied form, structure and color that
constitutes the vital living source
from which art must basically stem.*
—Kenneth Callahan

A self-taught painter and sculptor from
Washington state, Kenneth Callahan
thought that the natural world pro-
vided an infinite source of creative
ideas. Wanting to see with both "the
inner and outer eye," he believed an
idea and its artistic expression should
evolve together. Most importantly, he
stressed the transitory nature of all life,
the interconnectedness of all things,
and the concept of change as a posi-
tive element in the evolution of the
human spirit.

In *Rocks and Surf*, a tempera
painting of 1967, Callahan revealed
what he called "the unending process
of the evolving of forms and the disso-
lution of forms." Here, he used the
eternal ebb and flow of breaking
waves on the shoreline to represent
the transience of the physical uni-
verse. Though he painted from direct
observation, Callahan emphasized the
abstract qualities of water and rocks,
the mysterious sense of light and
shadow, and the shallow space of the
composition itself to create an evoca-
tive portrait of the sea. In the fore-
ground, small, ghostlike birds appear
to feed along the shore, perhaps a
visual reminder of the life-giving quali-
ties of the ocean.

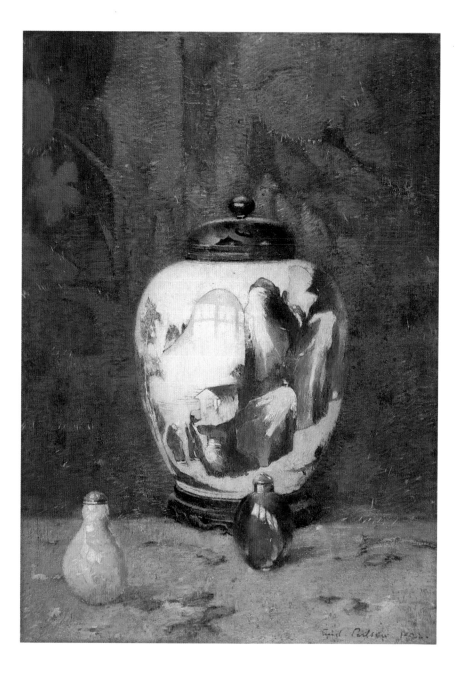

Søren Emil Carlsen
(1853–1932)
Still Life, Chinese Vase, 1922

Oil on wood panel
14 x 10 inches
Signed and dated, lower right: *Emil
Carlsen 1922*
RLH 161

PROVENANCE
Portland Art Museum, Portland, Oregon
Richard Lewis Hillstrom, Saint Paul,
1953

EXHIBITIONS
University Gallery, University of
Minnesota, Minneapolis, 1982

REFERENCES
Mary Towley Swanson, *The Divided
Heart: Scandinavian Immigrant
Artists, 1850–1950* (Minneapolis:
University of Minnesota Gallery, 1982),
no. 11, repr.

A noted painter of still lifes, Emil
Carlsen immigrated to America from
Denmark in 1872 at the age of nine-
teen. Shortly thereafter, he taught at
the Art Institute of Chicago before
returning to Europe in 1875 to study
the works of the eighteenth-century
French still-life painter Jean-Baptiste-
Siméon Chardin. Working in Paris
and later in New York, Carlsen
became the leading American propo-
nent of the nineteenth-century
Chardin revival.

Still Life, Chinese Vase, an oil on
panel completed in 1922, epitomizes
the late phase of Carlsen's career,
when his emulation of Chardin
achieved its highest level. With an
economy of means and attention to
the subtleties of light, form, and tex-
ture, Carlsen captured both the quiet
mood and soft atmosphere of the
French master. The still life's harmo-
nious colors and balanced arrange-
ment of objects add to its serenity
and contemplativeness.

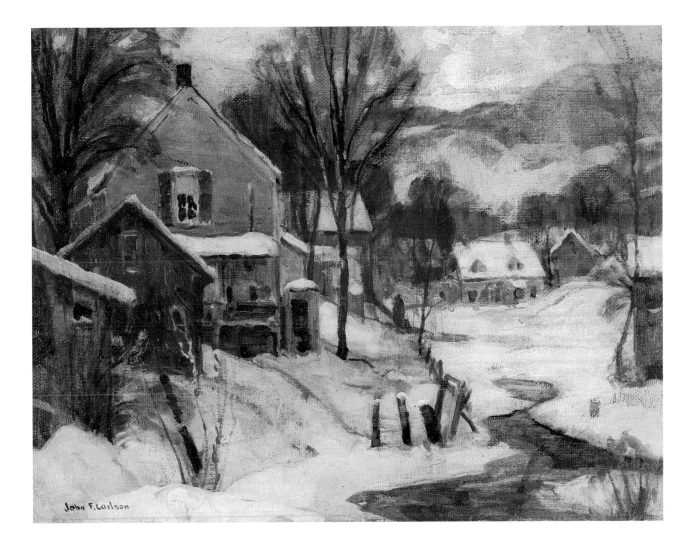

John F. Carlson
(1874-1945)
Thawing Snows, about 1930-35

Oil on canvas, mounted on wood panel
12 x 16 inches
Signed lower left: *John F. Carlson*
RLH 157

PROVENANCE
Acquired from the artist by Richard
Lewis Hillstrom, Saint Paul, 1944

EXHIBITIONS
American Swedish Institute,
Minneapolis, 1976
University Gallery, University of
Minnesota, Minneapolis, 1982

REFERENCES
Mary Towley Swanson, *The Divided*

*Heart: Scandinavian Immigrant
Artists, 1850-1950* (Minneapolis:
University of Minnesota Gallery, 1982),
no. 12.

A noted landscape painter and educa-
tor, John F. Carlson is best known for
his lyrical winter scenes of rustic New
England. Trained in New York at the
Art Students League during the first
decade of the twentieth century,
Carlson worked in a realist style that
was strongly influenced by French
Impressionism. Chief among his aes-
thetic concerns was how light, atmos-
phere, and season affected the mood
of a landscape. For much of his career,

Carlson lived in Woodstock, New
York, where he directed the Art
Students League Summer School and
later founded the Carlson School of
Landscape Painting.

Thawing Snows, an oil painting
from the 1930s, illustrates Carlson's
penchant for depicting landscapes
under specific seasonal and climatic
conditions. Here, he portrayed a pic-
turesque New England village on a
mild, late winter afternoon. Though
there are several dwellings in the
composition, no inhabitants are visi-
ble, conveying a sense of solitude,
even loneliness. The painting glows
with an overall silvery tone, one of
Carlson's trademarks, and displays his
characteristic expressive brushwork
and high-key palette.

Jon Corbino

(1905–64)

Sunday Afternoon (Rockport, Massachusetts), about 1935

Oil on canvas
9 x 18 inches
Signed lower left: *Corbino*
RLH 307

PROVENANCE
[Frank K. M. Rehn Gallery, New York]
Richard Lewis Hillstrom, Saint Paul,
1972

Widely admired as a romantic-realist artist, Jon Corbino won fame for his heroic compositions of figures engaged in vigorous activity. A consummate draftsman and painter, his dramatic canvases featured natural disasters, religious imagery, and vibrant celebrations of America at leisure. Filled with an energy and excitement that recall the work of such Old Masters as Peter Paul Rubens, Michelangelo, and Tintoretto, Corbino's paintings, with their tumultuous and often violent scenes, also show the influence of the great French romantic Eugène Delacroix.

To escape the intensity of his life in New York, Corbino spent summers in the small coastal town of Rockport, Massachusetts. There, he made tranquil views of the surrounding landscape and its inhabitants. In the painting here, he portrayed a group of vacationers enjoying a warm summer day at the beach. Sailboats drift lazily in the nearby bay, and Corbino's brilliant colors and spontaneous brushstrokes add to the sunny effect. One of his favorite settings, this locale also appears in several other works Corbino completed during the 1930s.

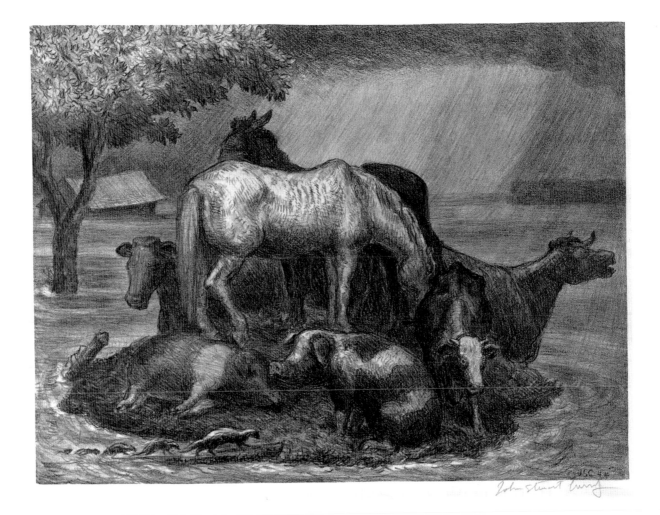

John Steuart Curry
(1897–1946)
Sanctuary, 1944

Lithograph on wove paper, edition
of 250
11¾ x 15¾ inches (image)
14 x 18⅜ inches (sheet)
Signed with initials and dated on stone:
JSC 44
Signed beneath image, lower right: *John
Steuart Curry*
Gift of Richard L. Hillstrom, The
Minneapolis Institute of Arts P.91.4

PROVENANCE
[Associated American Artists Gallery,
Chicago]
Richard Lewis Hillstrom, Saint Paul,
1946
The Minneapolis Institute of Arts, 1991

EXHIBITIONS
Lutheran Brotherhood, Minneapolis,
1975
University Gallery, University of
Minnesota, Minneapolis, 1976
(exhibition traveled to Carleton College,
Northfield, Minnesota; Rochester Art
Center, Rochester, Minnesota; Noble
County Art Center, Worthington,
Minnesota; Willmar Community
College, Willmar, Minnesota; Owatonna
Art Center, Owatonna, Minnesota;
Winona Art Center, Winona, Minnesota;
Metropolitan Community College,
Minneapolis; Cedar Rapids Art Center,
Cedar Rapids, Iowa)
The Minneapolis Institute of Arts, 1990

REFERENCES
Sylvan Cole, Jr., *The Lithographs of
John Steuart Curry: A Catalogue
Raisonné* (New York: Associated
American Artists, 1976), no. 38.
Mariea Caudill, *The American Scene:
Urban and Rural Regionalists of the
'30s and '40s* (Minneapolis: University
of Minnesota Gallery, 1976), no. 8.

A realist painter, illustrator, and print-
maker, John Steuart Curry is best
remembered as one of the leading
regionalist artists of the 1930s and
1940s. Like his contemporaries Thomas
Hart Benton and Grant Wood, Curry
earnestly sought a uniquely American
iconography and mythology. His
works focused on historical themes,
circus scenes, and, most commonly,
the drama of rural American life.

In *Sanctuary*, a 1944 lithograph,
Curry explored the universal struggle
against nature. With an obvious refer-
ence to the story of Noah and the Ark,
he pictured several pairs of farm ani-
mals and a family of skunks caught in
a torrential rainstorm. They huddle
together on a tiny parcel of high
ground, their temporary refuge from
the rising floodwaters. Based on a
series of drawings of floods in the
Kaw River Valley near Lawrence,
Kansas, which Curry observed in
1929, the print represents his final
interpretation of the subject. His ini-
tial depiction of the scene, an oil
painting of 1935, was followed by a
watercolor in 1936. In 1944, he made
at least two more sketches of the
composition before creating two litho-
graphic versions the same year,
including the one shown here.

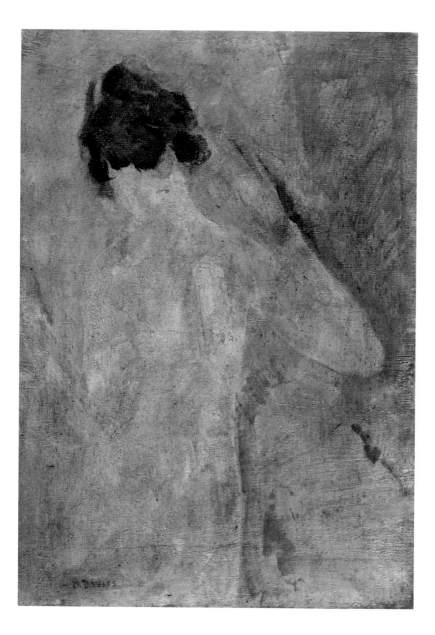

Arthur B. Davies
(1862–1928)
Figure Study, undated

Oil on wood panel
11 x 8 inches
Signed lower left: *A B Davies*
RLH 139

PROVENANCE
Estate of the artist, 1928
[James Graham & Sons Gallery, New
York]
Richard Lewis Hillstrom, Saint Paul,
1961

EXHIBITIONS
Walker Art Center, Minneapolis, 1964
Red River Art Center, Moorhead,
Minnesota, 1966
The Minneapolis Institute of Arts,
Minneapolis, 1969

Birger Sandzén Memorial Gallery,
Lindsborg, Kansas, 1972
College of Saint Catherine, Saint Paul,
1986
Minnesota Museum of Art, Saint Paul,
1986
Gustavus Adolphus College, Saint Peter,
Minnesota, 1987

REFERENCES
Collector's Club Exhibition IV
(Minneapolis: Center Arts Council,
1964).
Barbara Crawford Glasrud, *Three
Hundred Years of American Art*
(Moorhead, Minn.: Red River Art
Center, 1966), no. 23.

Though not a modern artist himself,
Arthur B. Davies enthusiastically pro-
moted the American avant-garde and
played a leading role in organizing the
famous Armory Show of 1913. He was
also a member of The Eight, but unlike
them, he was not a realist painter.
Often classically inspired and always
fiercely independent, Davies preferred
poetic, idyllic scenes with figures in
pastoral settings. In fact, the human
figure usually played a dominant role
in much of his work. In the undated
oil painting here, the softly modeled
female nude, seen from behind,
emerges from a hazy, indistinct back-
ground. By eliminating all extraneous
detail, Davies established form through
his broad brushwork and muted col-
ors, evoking the mysterious and
romantic aura that remained central to
his art. Quickly executed in thinly
applied oils, this work was probably a
compositional or color study for
another, perhaps larger, painting.

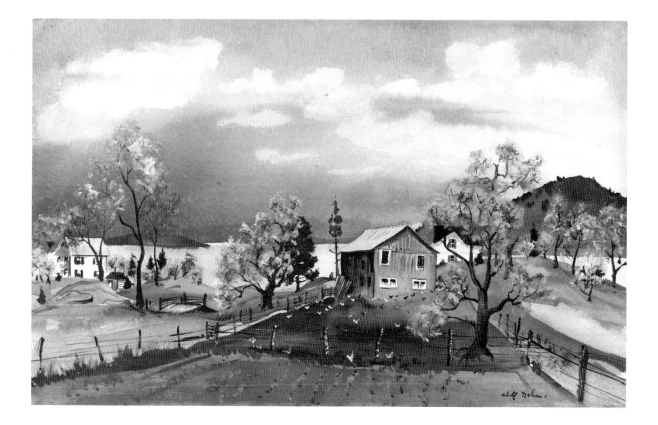

Adolf Dehn

(1895–1968)

Spring on the Hudson, 1954

Watercolor and gouache over graphite on paper
13¼ x 21⅛ inches
Signed lower right: *Adolf Dehn*
Signed, dated, and inscribed, verso: *Adolf Dehn June 1954/443 W. 21/ NYC/Anderson's Place on the Hudson* RLH 134

PROVENANCE
[Milch Galleries, New York]
Richard Lewis Hillstrom, Saint Paul, 1961

EXHIBITIONS
The Minneapolis Institute of Arts, Minneapolis, 1970
Lutheran Brotherhood, Minneapolis, 1975
Saint Olaf College, Northfield, Minnesota, 1976

When the eye, the heart and the brain, and the hand merge into spontaneous gesture, you have drawing.
　　　　　　　　　—Adolf Dehn

Best known for his satirical interpretations of urban life, Adolf Dehn also produced many watercolors of landscapes beginning in 1937. Born and raised in rural Waterville, Minnesota, Dehn expressed a profound love of the out-of-doors throughout his long career. But surprisingly, he never worked directly from nature, preferring instead to allow his compositions to emerge from his recollections of a scene, aided only by notes and rudimentary sketches.

Completed in 1954, *Spring on the Hudson* portrays a quiet, picturesque farm along the Hudson River in New York state. With fluid, spontaneous brushwork and a limited palette of greens and grays, Dehn captured the subtle atmosphere and mood of the rustic landscape. By accentuating the strange light of the threatening skies, he aptly conveyed the calm, though unsettled, feelings associated with an approaching storm. Suggestive of Chinese landscape painting, which Dehn admired, the watercolor, with its harmonious arrangement of distinct elements, also reveals the lyrical power of the countryside. According to Harold Milch, the artist's New York dealer, Dehn had long kept this painting in his studio, reluctant to part with it because he felt it contained nearly every characteristic of his work.

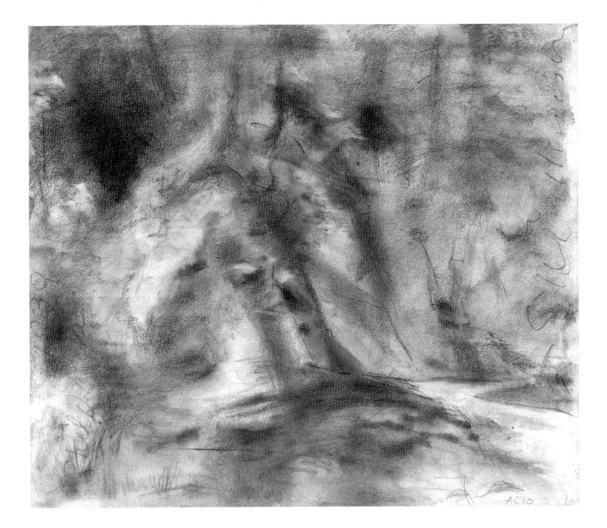

Edwin W. Dickinson
(1891–1978)
Prow, Wyer's Glen, 1939

Graphite on paper
11 x 13 inches
Signed vertically along right-hand edge:
E. W. Dickinson
Dated and inscribed vertically along left-hand edge: *1939/Sheldrake*
Signed with initials, dated and inscribed verso: *"Prow," Wyers Glen/1939 EWD*
RLH 249

PROVENANCE
[James Graham & Sons Gallery, New York]
Richard Lewis Hillstrom, Saint Paul, 1968

EXHIBITIONS
Gustavus Adolphus College, Saint Peter, Minnesota, 1969
The Minneapolis Institute of Arts, Minneapolis, 1970
Lutheran Brotherhood, Minneapolis, 1975
Saint Olaf College, Northfield, Minnesota, 1976

An enormously complex artist, Edwin Dickinson might best be described as a romantic visionary, a free-spirited independent whose reliance on intuition, dream, and memory placed him outside the mainstream of American modernism. Although his works are rooted in traditional naturalism, they usually feature mysterious settings, vague lighting, and ambiguous spatial arrangements. But regardless of subject matter or medium, Dickinson was particularly concerned with the interrelationship of forms within the pictorial space and always sought to create harmonious three-dimensional designs.

One of many landscape drawings completed during the 1930s, *Prow, Wyer's Glen* was conceived as an independent work of art. The nearly abstract composition features a mysterious world veiled in a luminous haze, where ghostly forms seem to emerge from the surrounding atmosphere. The effect is that of a dream: lyrical and elusive. Although they may appear to be nothing more than imaginary visions, Dickinson's landscapes are, in fact, views of actual places. In this case, Wyer's Glen is a forest near the artist's country home in Sheldrake, New York, and "Prow" refers to a prominent rock formation found there, visible in the center of the composition.

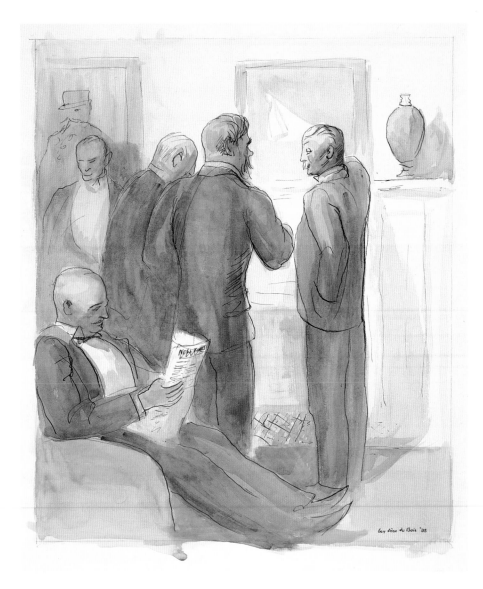

Guy Pène du Bois
(1884–1958)
Connoisseurs, 1938

Watercolor and black ink on paper
17⅛ x 13½ inches
Signed and dated, lower right: *Guy Pène du Bois '38*
RLH 120

PROVENANCE
Estate of John Kraushaar
[Kraushaar Galleries, New York]
Richard Lewis Hillstrom, Saint Paul,
1959

EXHIBITIONS
Walker Art Center, Minneapolis, 1964
The Minneapolis Institute of Arts,
Minneapolis, 1970
Lutheran Brotherhood, Minneapolis,
1975

Saint Olaf College, Northfield,
Minnesota, 1976
University Gallery, University of
Minnesota, Minneapolis, 1981

REFERENCES
Collector's Club Exhibition IV
(Minneapolis: Center Arts Council,
1964).
*Contact: American Art and Culture,
1919–1939* (Minneapolis: University of
Minnesota Gallery, 1981).

Although he studied with the realist
artists Robert Henri and Kenneth
Hayes Miller, Guy Pène du Bois
avoided his teachers' taste for seamy
urban scenes, preferring instead to
paint fashionable American society.

Displaying a talent for characteriza-
tion as well as a sympathetic wit, he
often portrayed satirical themes, as
shown in this 1938 watercolor. In
Connoisseurs, Pène du Bois poked
fun at the upper class, where a dis-
play of artistic knowledge seems to be
a sign of proper cultural decorum. In
the simple style of an illustrator, he
depicted a group of well-dressed,
older gentlemen relaxing at their pri-
vate club. Three of the men stand
before a seascape with a sailboat, pre-
sumably discussing its aesthetic mer-
its. In this social context, where an
individual's outer appearance and
behavior become an integral aspect of
identity, conformity becomes essen-
tial. With a trace of cynicism, Pène du
Bois chided those who embrace art
merely for its practical value as a sym-
bol of wealth and position.

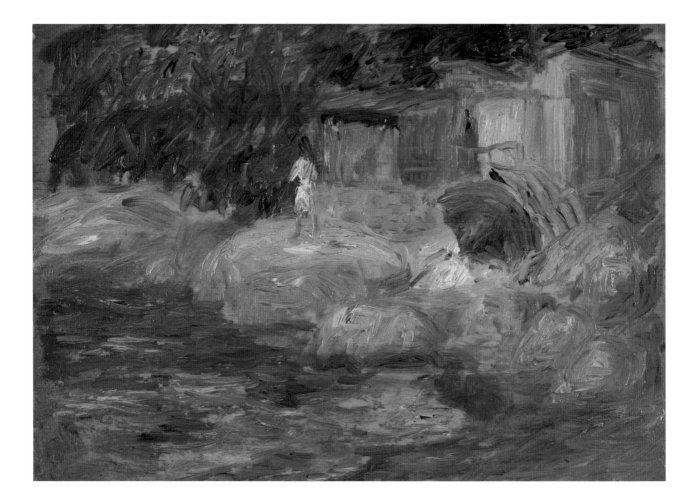

William J. Glackens
(1870–1938)
Summer Landscape (Bellport, Long Island), about 1911–16

Oil on wood panel
6 x 8⅜ inches
Unsigned
Estate stamp verso: *W. G./by E. G.*
RLH 112

PROVENANCE
Estate of the artist, 1938
[Kraushaar Galleries, New York]
Richard Lewis Hillstrom, Saint Paul,
1957

EXHIBITIONS
Walker Art Center, Minneapolis, 1964
The Minneapolis Institute of Arts,
Minneapolis, 1969
Birger Sandzén Memorial Gallery,
Lindsborg, Kansas, 1972
College of Saint Catherine, Saint Paul,
1986

Minnesota Museum of Art, Saint Paul,
1986
Gustavus Adolphus College, Saint Peter,
Minnesota, 1987

REFERENCES
Collector's Club Exhibition IV
(Minneapolis: Center Arts Council,
1964).

A widely acclaimed painter and illustrator, William J. Glackens began his career as an artist-reporter in Philadelphia, where he first became associated with John Sloan, George Luks, Everett Shinn, and Robert Henri. All would later join Glackens as members of The Eight, a progressive group of realists who exhibited together in 1908. After 1914, Glackens moved away from illustration and devoted himself to painting. While traveling in Europe, he became strongly influenced by the vibrant

color and informal themes of the French Impressionists, especially of Pierre Auguste Renoir. And like the Impressionists, Glackens chose to portray the simple joys of everyday life.

From 1911 to 1916, Glackens summered with his family in Bellport, Long Island, a coastal community fifty miles east of Manhattan. While there, he painted the local terrain, preferring lively waterfront scenes that depicted groups of people at leisure. *Summer Landscape*, an oil painting on panel, was completed during this period and shows a young girl quietly standing along a rocky shoreline. Several wooden buildings and a stand of trees serve as background. Though undoubtedly conceived as a preliminary study, the painting, made directly from nature, nevertheless reveals Glackens's spontaneous, expressive brushwork and saturated, high-key colors.

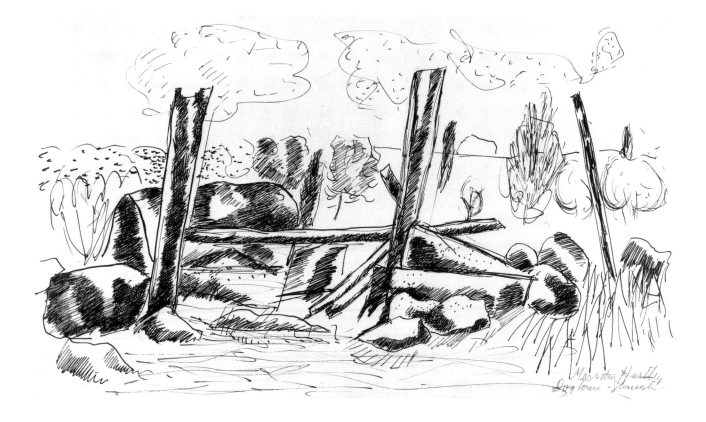

Marsden Hartley

(1877-1943)

Landscape with Fence Posts and Rocks (Dogtown Common), about 1934-36

Black ink on paper
9⅞ x 17 inches
Signed and inscribed, lower right:
*Marsden Hartley/Dog Town—
Gloucester*
RLH 103

PROVENANCE

Estate of the artist, 1943
[Babcock Galleries, New York]
Richard Lewis Hillstrom, Saint Paul, 1957

EXHIBITIONS

Lutheran Brotherhood, Minneapolis, 1975
Saint Olaf College, Northfield, Minnesota, 1976
College of Saint Catherine, Saint Paul, 1986
Gustavus Adolphus College, Saint Peter, Minnesota, 1987
Minnesota Museum of Art, Saint Paul, 1989

One of the pioneers of American modernism, Marsden Hartley experimented with a range of artistic styles during his career, including Fauvism, Cubism, and German Expressionism. In 1930, in response to criticism that his art lacked an independent vision, Hartley returned to the United States from Europe, where he had lived and worked for nearly a decade. Weary of European modernism and its formalist qualities, he decided to become "a fine realist."

In his search for a renewed artistic identity, Hartley returned to Gloucester, Massachusetts, in 1931, and an area outside the city known as Dogtown Common, which he had first visited twelve years earlier. A stark glacial moraine, the common was the site of a small village that had been abandoned in 1750, and only large granite boulders and crumbling stone walls remained. Believing Dogtown to be a metaphysical place, Hartley hoped its isolation would allow him to find a deeper meaning in his art and life. "The place is forsaken and majestically lovely," he wrote, "as if nature had at last formed one

spot where she can live for herself alone. . . . [It] looked like a cross between Easter Island and Stonehenge— essentially druidic in its appearance— it gives the feeling that an ancient race might turn up at any moment and renew an ageless rite there."[1]

At Dogtown, Hartley created haunting landscapes out of the fantastic rock formations and jutting fence posts. In three series on the subject, executed in 1931, 1934, and 1936, Hartley's mature realist style of blocky forms and somber colors emerged. Though he sometimes worked directly from nature, more often he would paint in his studio from sketches or memory. *Landscape with Fence Posts and Rocks*, probably completed in 1934 or 1936, represents only one of the numerous drawings he made of the site. Done at a pivotal point in his career, it shows his fondness for presenting objects frontally and with heavy outlines.

[1] Gail R. Scott, *Marsden Hartley* (New York: Abbeville Press, 1988), p. 90.

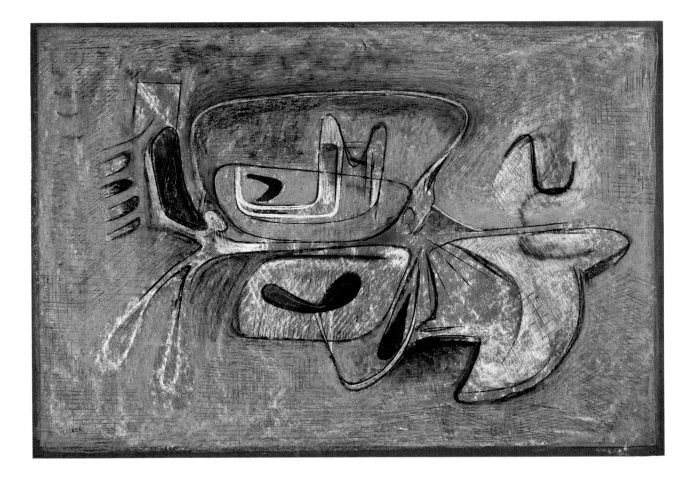

John E. Heliker

(born 1909)
Voyage, 1948

Pastel on black charcoal paper
14¼ x 21¼ inches
Signed lower left: *Heliker*
RLH 261

PROVENANCE
[Kraushaar Galleries, New York]
Richard Lewis Hillstrom, Saint Paul,
1968

EXHIBITIONS
Whitney Museum of American Art, New
York, 1968
Gustavus Adolphus College, Saint Peter,
Minnesota, 1969
Lutheran Brotherhood, Minneapolis,
1975
Saint Olaf College, Northfield,
Minnesota, 1976

REFERENCES
Lloyd Goodrich and Patricia FitzGerald
Mandel, *John Heliker* (New York:
Whitney Museum of American Art,
1968), no. 80, repr.

In 1954, John Heliker wrote that modern artists had created "a whole new conception of what painting is . . . the idea of a painting not as a literal transcription of natural objects telling a story, but as a unity, a microcosmos, in which each element, including the subject, plays an equal and significant role, so that the painting contains a message of order far beyond literal interpretation of objects."[1] From the beginning of his career, this central idea has shaped the artist's work. Heliker's early paintings were representational, especially of rural landscapes and nature studies. But in the mid-1940s, he began to experiment with abstraction.

Voyage, a pastel drawing of 1948, reflects this Surrealist phase—a transitional period for him when dreamlike images suggestive of natural forms dominated his pictures. Here, he relied on complex geometrical patterns of varying texture to create a tangible, though mysterious, object that emerges from an indistinct background like some ancient hieroglyph. Though his Surrealist phase lasted only a few years, Heliker continued to make abstract compositions in later life and to explore the structural harmonies created by a balanced use of color, line, and form.

[1] Lloyd Goodrich and Patricia FitzGerald Mandel, *John Heliker* (New York: Whitney Museum of American Art, 1968), p. 5.

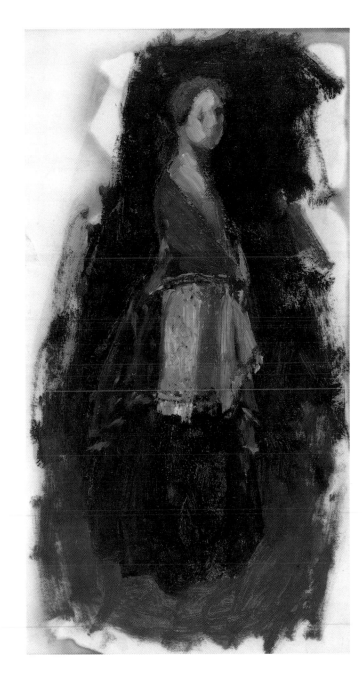

Robert Henri
(1865–1929)
Figure in Costume, undated

Oil on paper
15¾ x 9¼ inches
Unsigned
RLH 116

PROVENANCE
John Sloan, New York
[Kraushaar Galleries, New York]
Richard Lewis Hillstrom, Saint Paul,
1960

EXHIBITIONS
Walker Art Center, Minneapolis, 1962
Red River Art Center, Moorhead,
Minnesota, 1966
Birger Sandzén Memorial Gallery,
Lindsborg, Kansas, 1972
College of Saint Catherine, Saint Paul,
1986
Minnesota Museum of Art, Saint Paul,
1986
Gustavus Adolphus College, Saint Peter,
Minnesota, 1987

REFERENCES
Third Exhibition (Minneapolis: Center
Arts Council, 1962).
Barbara Crawford Glasrud, *Three
Hundred Years of American Art*
(Moorhead, Minn.: Red River Art
Center, 1966), no. 20.

As the spiritual leader of a small band
of American realists known as The
Eight, or the Ashcan School, Robert
Henri believed that art grew directly
from the experiences of life, not from
theories. Both as a teacher and as a
painter, he rejected conventional aca-
demic styles and stressed that artists
should above all rely on their own
innate feelings and subjective
responses. Stating that he wanted his
pictures to be "as clear and as simple
and as sincere as . . . possible,"[1] he
chose the human figure as his primary
subject and through his respectful
and sympathetic portrayals hoped to
record the essence of human nature.

In *Figure in Costume*, an oil
sketch on paper, Henri's rapid, slash-
ing brushwork and use of dark tonali-
ties and stark contrasts becomes
apparent. Strongly influenced by the
painterly bravado and rich colors of
such European masters as Frans Hals,
Velázquez, and Edouard Manet, Henri
always placed his sitters against neu-
tral, indefinable backgrounds. With
only a minimum of detail, the com-
position readily shows a woman
wearing a full-length costume. This
rapidity of style underscored Henri's
belief that such immediacy could
best capture the living presence of
the subject.

[1]Matthew Baigell, *Dictionary of Ameri-
can Art* (New York: Harper & Row,
1979), p. 162.

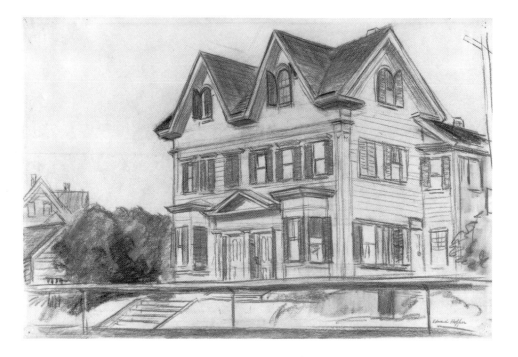

Edward Hopper
(1882-1967)
Double House, Gloucester,
about 1923-28

Conté crayon on paper
12 x 18 inches
Signed lower right: *Edward Hopper*
Inscribed verso: *Double House
Gloucester*
Gift of Richard L. Hillstrom in memory
of his parents, Alma and Martin
Hillstrom, The Minneapolis Institute of
Arts 86.113

PROVENANCE
[Frank K. M. Rehn Gallery, New York]
Richard Lewis Hillstrom, Saint Paul, 1957
The Minneapolis Institute of Arts, 1986

EXHIBITIONS
Saint Paul Gallery of Art, Saint Paul, 1958
Walker Art Center, Minneapolis, 1962
Whitney Museum of American Art, New
York, 1964
Red River Art Center, Moorhead,
Minnesota, 1966
The Minneapolis Institute of Arts,
Minneapolis, 1969, 1971, 1983
University Gallery, University of
Minnesota, Minneapolis, 1974
Lutheran Brotherhood, Minneapolis,
1975
Saint Olaf College, Northfield,
Minnesota, 1976
Goldstein Gallery, University of
Minnesota, Saint Paul, 1980
Minnesota Museum of Art, Saint Paul,
1981

College of Saint Catherine, Saint Paul,
1986

REFERENCES
Third Exhibition (Minneapolis: Center
Arts Council, 1962).
Lloyd Goodrich, *Edward Hopper* (New
York: Whitney Museum of American
Art, 1964), no. 147.
Barbara Crawford Glasrud, *Three
Hundred Years of American Art*
(Moorhead, Minn.: Red River Art
Center, 1966), no. 27, repr.
*Drawings and Watercolors from
Minnesota Private Collections*
(Minneapolis: The Minneapolis Institute
of Arts, 1971), no. 60, repr.
Donna Isaac, *New York Artists of the
1920's* (Minneapolis: University of
Minnesota Gallery, 1973).
Thomas S. Holman, *American Style:
Early Modernist Works in Minnesota
Collections* (Saint Paul: Minnesota
Museum of Art, 1981), no. 36, repr.

Edward Hopper, one of America's
leading twentieth-century realists,
possessed a keen interest in architec-
ture throughout his career. He was
especially fascinated with solitary
dwellings, choosing them not for
their intrinsic beauty, but for their
formal, structural qualities. And as a
painter of the American scene, he
usually portrayed the isolation and
alienation of human existence, emo-
tions he sometimes conferred on
inanimate objects as well.

In *Double House, Gloucester*, a
conté crayon study from the mid-

1920s, Hopper depicted the exterior
of a typical and unremarkable New
England dwelling. Hopper had first
visited the small coastal community of
Gloucester, Massachusetts, during the
summer of 1912 and made several
trips there during the 1920s. Each
time, he was particularly struck by the
town's architecture. "At Gloucester
when everyone else would be paint-
ing ships and the waterfront," he
once wrote, "I'd just go around look-
ing at houses. It is a solid looking
town. The roofs are very bold, the
cornices are bolder. The dormers cast
very positive shadows. The sea cap-
tain influence I guess—the boldness
of ships."[1]

Hopper recorded this boldness of
form here in a concise and confident
manner, concentrating on the build-
ing's elaborate pattern of windows,
shutters, doors, and classical details.
He also included one of his favorite
visual devices—a strong horizontal
element across the foreground that
serves as an anchor for the picture's
more complex forms. In this regard,
the modern art critic Alfred Barr once
stated that these horizontals "are like
the edge of a stage beyond which
[the] drama unfolds."[2]

[1]Gail Levin, *Edward Hopper: The Art and
the Artist* (New York and London: W. W.
Norton & Co., 1980), p. 44.
[2]Lloyd Goodrich, *Edward Hopper* (New
York: Whitney Museum of American Art,
1964), p. 52.

John Frederick Kensett
(1816-72)
Study of Trees, about 1860

Graphite on pale green paper
10¼ x 14⅛ inches
Unsigned
RLH 286

PROVENANCE
H. Shaw Newman
Paul Magriel
[Zabriskie Gallery, New York]
Richard Lewis Hillstrom, Saint Paul,
1969

EXHIBITIONS
Lutheran Brotherhood, Minneapolis,
1975
Saint Olaf College, Northfield,
Minnesota, 1976

*I long to get amid the scenery of my
own country for it abounds with the
picturesque, the grand, and the
beautiful—to revel among the strik-
ing scenes which a bountiful hand
has spread over its wide-extended
and almost boundless territory.*
—John F. Kensett

One of America's premier landscape
painters of the nineteenth century,
John F. Kensett also was a dedicated
and masterly draftsman who made
numerous sketches throughout his
career. *Study of Trees* characterizes
his graphic efforts. From his days as
an art student in Paris until his death
in 1872, Kensett took sketching
tours to Europe and along the East
Coast of the United States. As a result
of these excursions, he amassed a
large inventory of nature studies
that subsequently became source
material for his paintings. As here,
many of these drawings featured
isolated elements in the landscape—
often a single tree—that Kensett
could later use for the details in his
oil paintings.

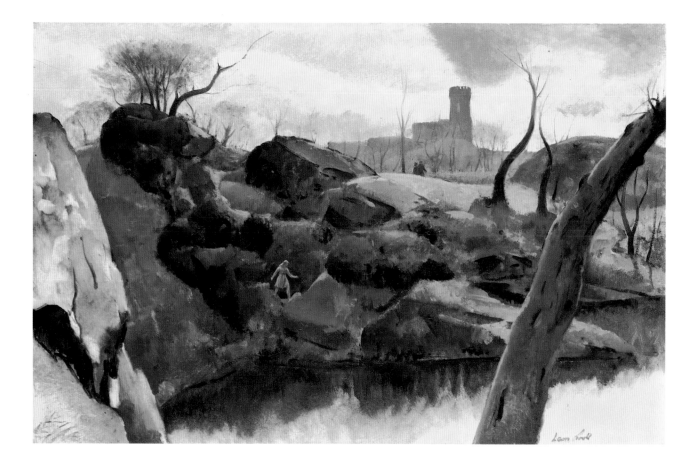

Leon Kroll
(1884–1974)
Central Park, New York, 1937

Oil on Masonite panel
18 x 28 inches
Signed lower right: *Leon Kroll*
RLH 202

PROVENANCE
[Milch Galleries, New York]
Richard Lewis Hillstrom, Saint Paul,
1964

EXHIBITIONS
Gustavus Adolphus College, Saint Peter,
Minnesota, 1969, 1987
College of Saint Catherine, Saint Paul,
1986
Minnesota Museum of Art, Saint Paul,
1989

For me, art is a religious devotion.
—Leon Kroll

An important painter, muralist, and
teacher in the early decades of the
twentieth century, Leon Kroll stead-
fastly championed American realism.
Acclaimed for his monumental female
nudes and expressive landscapes, he
was closely associated with such
artists as George Bellows, William
Glackens, John Sloan, and Eugene
Speicher. And in choosing themes
from everyday life, Kroll once wrote,
"I like motifs that are warm with
understanding; the natural gesture; the
touch of people; landscapes where
people live and work and play. The
living, breathing light over forms. I
sense the beyondness and the wonder
of simple living people and the things
they do. I try to express this feeling
without being too obvious about it."[1]

Central Park, New York, an oil
painting of 1937, comes from an
important series depicting life in New

York City. Here, Kroll concentrated
on the natural, untamed beauty of the
vast urban refuge. With Belvedere
Castle looming in the hazy distance
like some mysterious sentinel, the
scene is dominated by imposing rock
formations and oddly shaped tree
trunks. The artist also included three
figures, not as primary elements, but
as incidental inhabitants of the largely
barren terrain. "I always use nature as
a land of abstract encyclopedia of
fact," he stated. "I use parts and com-
pose a picture. And even while I'm
creating the space, I never copy
nature. As a matter of fact, you can't
copy nature. It's ridiculous. You just
make choices out of nature."[2]

[1]Leon Kroll, *Leon Kroll* (New York:
American Artists Group, 1946), n. pag.
[2]Fredson Bowers and Nancy Hale, eds.,
Leon Kroll: A Spoken Memoir (Charlottes-
ville, Va.: The University Press of Virginia,
1983), p. 106.

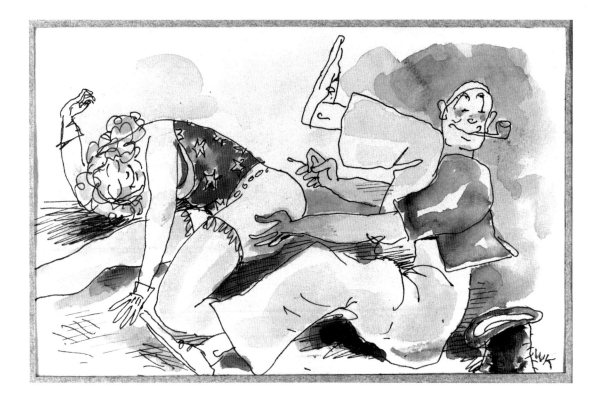

Walt Kuhn
(1877-1949)
Clowning Figures, undated

Watercolor over black ink on paper
3½ x 5½ inches
Signed with initials, lower right: *WK*
RLH 296

PROVENANCE
Estate of the artist, 1949
[Kennedy Galleries, New York]
Richard Lewis Hillstrom, Saint Paul,
1970

EXHIBITIONS
University Gallery, University of
Minnesota, Minneapolis, 1974
Lutheran Brotherhood, Minneapolis,
1975
Saint Olaf College, Northfield,
Minnesota, 1976
University Gallery, University of
Minnesota, Minneapolis, 1977
(exhibition traveled to Stillwater Public
Library, Stillwater, Minnesota; Saint Olaf
College, Northfield, Minnesota;
Princeton Public Library, Princeton,
Minnesota; Red Wing Public Library,
Red Wing, Minnesota; South Saint Paul
Public Library, South Saint Paul,
Minnesota; Marshall Public Library,
Marshall, Minnesota)

REFERENCES
Donna Isaac, *New York Artists of the
1920's* (Minneapolis: University of
Minnesota Gallery, 1973).
Mari Ann Barta, *Images of Women in
American Graphic Arts, 1900-1930*
(Minneapolis: University of Minnesota
Gallery, 1977).

A remarkably versatile artist, Walt
Kuhn explored a diverse range of
styles and themes throughout his life.
An early modernist painter who
helped organize the 1913 Armory
Show, he worked as an illustrator
and cartoonist for such magazines as
Life and *Puck* during the early years
of his career. In the late 1920s, he
began focusing almost entirely on
scenes of carnival and circus per-
formers. In this small ink-and-water-
color sketch, two clowns strike a
comical pose as one prepares to light
a match on the backside of the other.
Characteristic of Kuhn's energetic,
yet simple style, the witty scene was
recorded directly from life. Though
Kuhn left many of his compositions
undated, this drawing may have been
part of a series of circus subjects that
he completed in 1940.

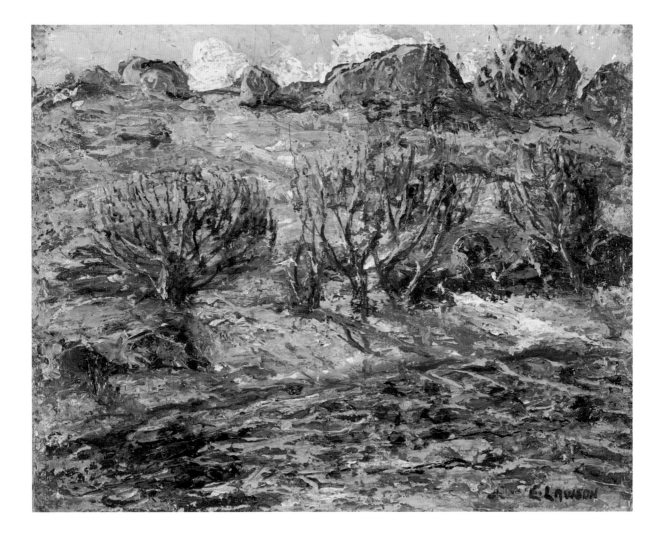

Ernest Lawson
(1873–1939)
Young Willows, about 1912

Oil on cardboard
8 x 10 inches
Signed lower right: *E. Lawson*
RLH 113

PROVENANCE
[The New Gallery, New York]
[Babcock Galleries, New York]
Richard Lewis Hillstrom, Saint Paul,
1956

EXHIBITIONS
Birger Sandzén Memorial Gallery,
Lindsborg, Kansas, 1972
College of Saint Catherine, Saint Paul,
1986
Minnesota Museum of Art, Saint Paul,
1986

Gustavus Adolphus College, Saint Peter,
Minnesota, 1987

*Movement in nature is my creed as
a landscapist and light and air are
my delight.*
—Ernest Lawson

A lifelong Impressionist and member
of The Eight, Ernest Lawson won
acclaim for his opulent landscape
paintings. Trained under the
American Impressionists Julian Alden
Weir and John Henry Twachtman,
Lawson always sought to convey both
the beauty and emotional power of

the natural world. And while, like his
realist friends in The Eight, he some-
times pictured urban scenes, he more
often depicted the open countryside
and isolated stands of trees.

In *Young Willows*, an oil from
about 1912, Lawson used brilliant
paints and rich texture to lend a
romantic aura to an otherwise unre-
markable vista. Here, the sunlit terrain
features several small willows grow-
ing beside a pond or stream. More
large trees and billowy clouds draw
the viewer's eye back into the dis-
tance. Using thickly applied color,
Lawson created a complex visual pat-
tern of lacey trees, vibrant reflections,
and intense hues. One writer,
inspired by the artist's dazzling sur-
faces, accurately described the effect
as a "palette of crushed jewels."

Roy Lichtenstein
(born 1923)
Brushstrokes, 1967

Color screenprint, edition of 300
22 x 30 inches (image)
23 x 31 inches (sheet)
Signed lower right: *rf Lichtenstein*
Gift of Richard L. Hillstrom in memory
of Irene and Edward Hillstrom, The
Minneapolis Institute of Arts P.84.42

PROVENANCE
[Leo Castelli Gallery, New York]
[Walker Art Center Gallery,
Minneapolis]
Richard Lewis Hillstrom, Saint Paul,
1967
The Minneapolis Institute of Arts, 1984

REFERENCES
Paul Bianchini, *Roy Lichtenstein:*
Drawings and Prints (New York:
Chelsea House, 1969), no. 20, repr.

One of the leaders of the American
Pop art movement, Roy Lichtenstein
began to appropriate images from
comic strips and commercial art in
1961 as subject matter for his paint-
ings and drawings. The cartoon, he
explained, "became a ready-made way
of doing everything I wanted to do—
everything you weren't supposed to
do all in one; it depicted and it out-
lined, but it brought it all into a really
modern painting . . . a completely
new expression."[1] Using techniques
that mimicked photomechanical
printing methods, he created near-
exact duplicates of popular images in
formats and mediums traditionally
reserved for fine art. His visual vocab-
ulary included dots and stripes; flat-
tened, simplified forms; bright,
unmodulated color; and bold outlines,
and he often expressed the desire to
remove all traces of the artist's hand
from the finished work.

Perhaps more than any of
Lichtenstein's motifs, the brushstroke,
as seen in this color screenprint of
1967, has itself become an icon of his
art. Parodying the painterly gesture,
Lichtenstein represents the brush-
stroke—the principal signature of the
artist—as an object in its own right,
floating it against a field of dots.
Published by the Pasadena Art
Museum in conjunction with
Lichtenstein's first retrospective,
Brushstrokes turns the spontaneous
gesture into the stereotyped image
and readily shows Pop's preference
for the impersonal and machine-made.

[1]Bernice Rose, *The Drawings of Roy*
Lichtenstein (New York: Museum of
Modern Art, 1987), p. 19.

George B. Luks
(1866-1933)
Miner's Wife, about 1925

Charcoal and black wash on paper
14½ x 8 inches
Signed lower right: *George Luks*
RLH 242

PROVENANCE
Clifford R. Hall, New Jersey, 1928
Mrs. Lesley G. Sheafer
[Frank K. M. Rehn Gallery, New York]
Richard Lewis Hillstrom, Saint Paul,
1959

EXHIBITIONS
Saint Paul Gallery and School of Art,
Saint Paul, 1960
The Minneapolis Institute of Arts,
Minneapolis, 1969
Lutheran Brotherhood, Minneapolis,
1975
Saint Olaf College, Northfield,
Minnesota, 1976
University Gallery, University of
Minnesota, Minneapolis, 1977 (exhibi-
tion traveled to Stillwater Public Library,
Stillwater, Minnesota; Saint Olaf College,
Northfield, Minnesota; Princeton Public
Library, Princeton, Minnesota; Red
Wing Public Library, Red Wing,
Minnesota; South Saint Paul Public
Library, South Saint Paul, Minnesota;
Marshall Public Library, Marshall,
Minnesota)
College of Saint Catherine, Saint Paul,
1986
Minnesota Museum of Art, Saint Paul,
1986
Gustavus Adolphus College, Saint Peter,
Minnesota, 1987

REFERENCES
Mari Ann Barta, *Images of Women in
American Graphic Arts, 1900-1930*
(Minneapolis: University of Minnesota
Gallery, 1977), n. pag.

George Luks began his career as a
newspaper illustrator in Philadelphia,
where he met fellow artists Everett
Shinn, John Sloan, William Glackens,
and Robert Henri, who would later
form the nucleus of The Eight.
Though fiercely independent, Luks
was strongly influenced by Henri's
dark, tonal style and by his adage to
"translate life into paint." An impor-
tant painter, illustrator, and cartoon-
ist in his own right, Luks gained
renown for his realistic portrayals of
ordinary people. Like many of his
contemporaries, Luks sought a

uniquely American art, often search-
ing urban slums for his subjects. Yet,
his art always exhibited an empathy
for the working poor, a sympathy
that originated from his childhood
experiences in the coal mining region
of central Pennsylvania.

During the 1920s, Luks returned
home several times, producing
numerous portraits and character
studies of the area's residents. *Miner's
Wife*, a charcoal-and-wash sketch
from this period, was drawn directly

from life and exhibits the bold, spon-
taneous brushwork and simplified
composition that characterized much
of Luks's work. Frontally posed and
holding a bucket, the woman here
wears simple, traditional clothing. By
omitting any indication of her physi-
cal surroundings, Luks focused on the
woman's expression and humble
appearance. But in his straightforward
and respectful manner, he captured
the essential dignity and strength of
his subject.

John Marin

(1870–1953)
Stonington Harbor, Deer Isle, Maine, 1923

Watercolor on paper
14½ x 10¾ inches
Signed and dated, lower right: *Marin/23*
Inscribed and dated, verso: *Stonington Harbor, Deer Isle, Me.—1923*
RLH 104

PROVENANCE

[The Downtown Gallery, New York]
Richard Lewis Hillstrom, Saint Paul, 1957

EXHIBITIONS

Saint Paul Gallery of Art, Saint Paul, 1958
Walker Art Center, Minneapolis, 1958
Gustavus Adolphus College, Saint Peter, Minnesota, 1964, 1987
Red River Art Center, Moorhead, Minnesota, 1966
The Minneapolis Institute of Arts, Minneapolis, 1969, 1971, 1976
Lutheran Brotherhood, Minneapolis, 1975
Saint Olaf College, Northfield, Minnesota, 1976
College of Saint Catherine, Saint Paul, 1986

REFERENCES

Second Collector's Club Exhibition (Minneapolis: Center Arts Council, 1958), no. 49.
Barbara Crawford Glasrud, *Three Hundred Years of American Art* (Moorhead, Minn.: Red River Art Center, 1966), no. 25.
Sheldon Reich, *John Marin, Part II: Catalogue Raisonné* (Tucson: University of Arizona Press, 1970), no. 23.17, repr.
Drawings and Watercolors from

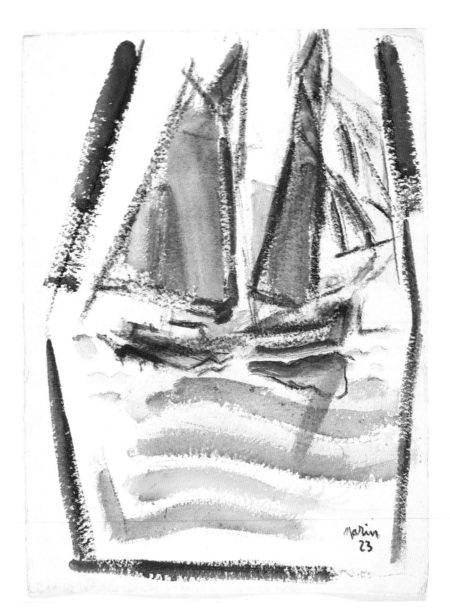

Minnesota Private Collections (Minneapolis: The Minneapolis Institute of Arts, 1971), no. 57, repr.

Art is just a series of natural gestures.
—John Marin

An acclaimed early modernist, John Marin gained renown for his dynamic watercolors of New York City and the New England coast. Though his early works showed his study of James Abbott McNeill Whistler and the French Nabis, Marin came under the influence of such European moderns as Paul Cézanne and Pablo Picasso during the 1910s. In his mature works, Marin became increasingly abstract and tried to convey the energetic forces of life through his expressive forms and colors.

In 1914, Marin first went to the state of Maine and regularly summered there after 1919. His profound love of nature and the ocean can be seen in *Stonington Harbor, Deer Isle, Maine*, a watercolor of 1923. Here, in a series of rapid gestural brushstrokes, he created an abstract depiction of sailboats and the sea. Restricting his palette to blue, green, red, yellow, and black, he also left large areas of the paper bare and framed his composition with bold lines to accentuate the tension between the flatness of the picture plane and the suggested depth of the pictorial image. Believing boats to be "lovely and dignified like solitary, self-sufficing individuals,"[1] Marin remained fascinated with sailing and seascapes throughout his long career.

[1]Paul Rosenfeld, "John Marin's Career," *New Republic* (April 14, 1937): 291.

Reginald Marsh

(1898-1954)
Manhattan Towers, 1932

Watercolor over graphite on paper
14 x 20 inches
Signed and dated, lower right: *Reginald Marsh '32*
RLH 138

PROVENANCE
Estate of the artist, 1954
[Frank K. M. Rehn Gallery, New York]
Richard Lewis Hillstrom, Saint Paul, 1961

EXHIBITIONS
Walker Art Center, Minneapolis, 1962
Gustavus Adolphus College, Saint Peter, Minnesota, 1964, 1987
Red River Art Center, Moorhead, Minnesota, 1966
Luther College, Decorah, Iowa, 1968
Lutheran Brotherhood, Minneapolis, 1975
University Gallery, University of Minnesota, Minneapolis, 1976 (exhibition traveled to Carleton College, Northfield, Minnesota; Rochester Art Center, Rochester, Minnesota; Noble County Art Center, Worthington, Minnesota; Willmar Community College, Willmar, Minnesota; Owatonna Art Center, Owatonna, Minnesota; Winona Art Center, Winona, Minnesota; Metropolitan Community College, Minneapolis; Cedar Rapids Art Center, Cedar Rapids, Iowa)
College of Saint Catherine, Saint Paul, 1986

REFERENCES
Third Exhibition (Minneapolis: Center Arts Council, 1962).
Barbara Crawford Glasrud, *Three Hundred Years of American Art* (Moorhead, Minn.: Red River Art Center, 1966), no. 29, repr.
Mariea Caudill, *The American Scene: Urban and Rural Regionalists of the '30s and '40s* (Minneapolis: University of Minnesota Gallery, 1976), no. 41, repr.

An admired painter, illustrator, and printmaker, Reginald Marsh chronicled the daily lives of people in New York City. As a student of John Sloan, George Luks, and Kenneth Hayes Miller, Marsh was associated with the Fourteenth Street School of urban realists and always sought to capture the pulse and energy of New York's crowded streets, beaches, and burlesque halls, what he called the "big picture of American life." In addition to his dynamic figure studies, Marsh also documented the physical structures of the city in both watercolor and etching from the early 1920s until the 1940s.

In this 1932 watercolor, Marsh presented a dramatic view of Midtown Manhattan from Brooklyn across the East River. Painted with a realism reminiscent of his work as a magazine illustrator, the panoramic vista features the Chrysler Building, which was erected in 1930. Subtly rendered in shades of blue and gray, the distant skyscrapers glisten with warm highlights. A loading crane and barge in dark earth tones dominate the foreground and contrast markedly with the elegant verticals and cool colors of the skyline.

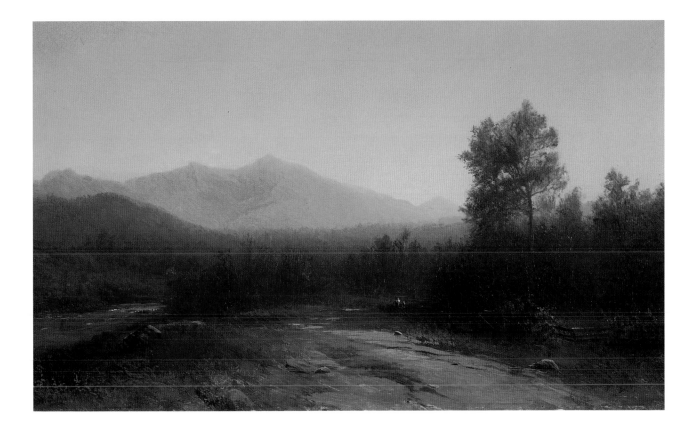

Homer Dodge Martin
(1836-97)
Hudson River Landscape,
undated

Oil on canvas
13⅞ x 24 inches
Signed lower left: *H. D. Martin*
RLH 206

PROVENANCE
[Kennedy Galleries, New York]
Richard Lewis Hillstrom, Saint Paul,
1965

EXHIBITIONS
Birger Sandzén Memorial Gallery,
Lindsborg, Kansas, 1972
Minnesota Museum of Art, Saint Paul,
1989

Admired for his panoramic views of the Hudson River Valley, Homer Dodge Martin was particularly concerned with evoking the spirit and mood of nature. Influenced by the landscapists Thomas Cole and John F. Kensett, he preferred to paint naturalistic scenes of the Catskill and Adirondack mountains in New York state.

In *Hudson River Landscape*, probably completed in the mid-1860s, Martin carefully detailed the light, atmosphere, and space of the idyllic riverbed. His use of naturalistic color and a balanced composition further enhances the inherent beauty and tranquillity of the setting. He included distant figures only as a visual reminder of humankind's insignificance in the face of nature's imposing majesty. Like many of his contemporaries, Martin usually painted his landscapes back in his studio, working from memory or preliminary sketches.

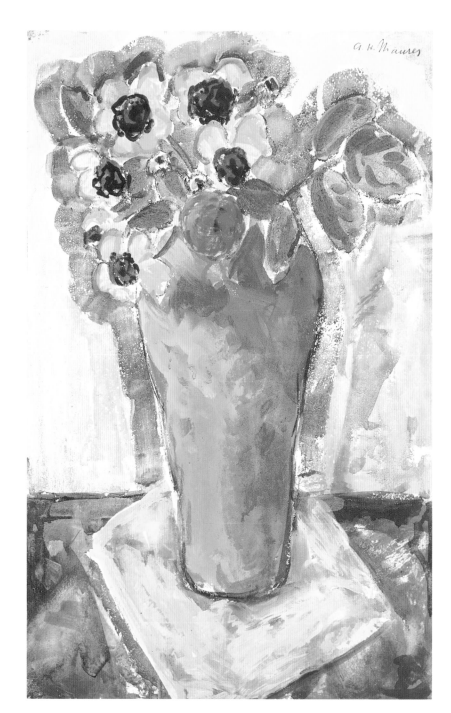

Alfred H. Maurer
(1868–1932)
Still Life with Vase of Flowers, about 1926–28

Gouache and watercolor on gessoed panel
18 x 11½ inches
Signed upper right: *A. H. Maurer*
RLH 109

PROVENANCE
Mrs. Dull, New York
Carmine Dalesio, New York
[Babcock Galleries, New York]
Richard Lewis Hillstrom, Saint Paul, 1957

EXHIBITIONS
Saint Paul Gallery of Art, Saint Paul, 1958
Walker Art Center, Minneapolis, 1958
College of Saint Catherine, Saint Paul, 1986
Gustavus Adolphus College, Saint Peter, Minnesota, 1987

REFERENCES
Second Collector's Club Exhibition (Minneapolis: Center Arts Council, 1958), no. 52.

Although widely recognized today as one of America's pioneer modernists, Alfred Maurer received virtually no critical acclaim for his art until the mid-1920s, some twenty years into his career. Then, Weyhe Gallery purchased the entire contents of Maurer's New York studio, with the promise to show his work regularly.

Spiritually renewed by the attention, Maurer returned to painting floral still lifes and figural studies, genres he had first investigated during his many years in Paris. Greatly admired for their exuberance and vitality, these pieces—many of them watercolors and gouaches—show the strong influence both Fauvism and Cubism had on the artist's mature style.

In its brilliant hues and geometric organization, *Still Life with Vase of Flowers*, completed between 1926 and 1928, typifies Maurer's handling of color and form. Broadly brushed in

pinks, yellows, and ochers, it features such Cubist elements as flattened forms, tilted planes, and simplified contours. The thinly applied pigments also enhance its spontaneous, unfinished quality, as does the ambiguous presentation of space, which constantly draws the viewer's attention back to the radiant surface of the work. The flowers, bursting forth in a rhythm of curving lines, act as counterpoint to the angular edges of the table, wall, and floor, while their halo of lavender light electrifies the cramped interior of the composition.

Willard Leroy Metcalf
(1858–1925)
Scene in Tunis, 1887

Oil on wood panel
10½ x 16⅛ inches
Signed and inscribed, lower left:
*Souvenir de Tunis/à mon ami J.
Barnes/W. L. Metcalf*
RLH 200

PROVENANCE
[Milch Galleries, New York]
Richard Lewis Hillstrom, Saint Paul,
1964

EXHIBITIONS
College of Saint Catherine, Saint Paul,
1986

Gustavus Adolphus College, Saint Peter,
Minnesota, 1987

A noted Impressionist and founding
member of the Ten American
Painters, Willard Metcalf is remem-
bered as "the poet laureate of the
New England hills." Initially trained in
Boston and later in Paris at the
Académie Julian under Gustave
Boulanger and Jules Lefebvre, Metcalf
was devoted to the plein-air method
and was widely admired for his swift
and direct techniques and images.

Like many nineteenth-century
academic artists, Metcalf ventured to
Africa for the clear light and exotic
subjects. He arrived in Biskra,
Algeria, in January 1887, and spent
two months there and in Tunis paint-
ing and sketching scenes of the
Sahara. This oil on panel dates from
that period and shows a Tunisian
market. The spontaneous depiction
deftly captures the bright light of the
North African desert, evoking a dis-
tinct sense of place. The painting
may have been one of several works
Metcalf used as models for his Paris
Salon entry of 1888, for which he
received an honorable mention.
The identity of the person men-
tioned in Metcalf's inscription
remains unknown.

59

Jerome Myers
(1867–1940)
Self-Portrait, about 1925

Oil, gouache, and pastel on cardboard
17⅛ x 13 inches
Signed lower right: *Jerome Myers/E. M.*
RLH 197

PROVENANCE
Estate of the artist, 1940
[Kraushaar Galleries, New York]
Richard Lewis Hillstrom, Saint Paul,
1964

EXHIBITIONS
Birger Sandzén Memorial Gallery,
Lindsborg, Kansas, 1972

Though less well known than some of
his contemporaries, Jerome Myers
numbered among the first American
artists to record scenes of New York's
Lower East Side. A gifted draftsman,
Myers portrayed the daily activities of
the people he encountered with a
personal and sympathetic brand of
realism. Unlike the gritty depictions
of The Eight, Myers's work revealed
the more lighthearted moments of
everyday life among the poor. In addi-
tion to the numerous urban scenes he
executed during his career, Myers
also created a large number of self-
portraits in a variety of media. This
self-portrait, from about 1925, charac-
terizes the type of psychologically
probing studies he preferred making.
Completed when Myers was in his
late fifties, the painting successfully
reveals the artist's introspective and
dignified nature. The work was signed
and initialed in charcoal by his wife,
Ethel, after his death.

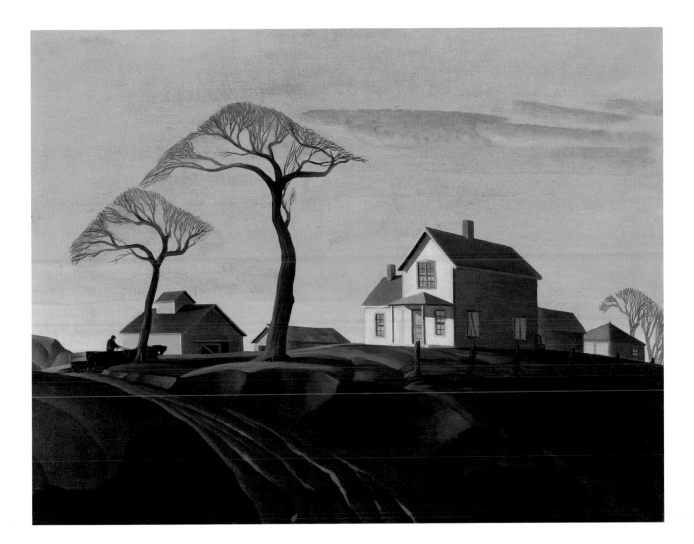

Dale Nichols
(born 1904)
The Twins, 1946

Oil on canvas
30 x 40 inches
Signed and dated, lower left: *Dale Nichols 1946*
RLH 305

PROVENANCE
[Grand Central Art Galleries, New York]
Richard Lewis Hillstrom, Saint Paul, 1971

EXHIBITIONS
Minnesota Museum of Art, Saint Paul, 1989

Though not well known outside his home state, Dale Nichols is noted for his idyllic depictions of Midwestern farms. In a manner suggestive of the famous regionalist artist Grant Wood, Nichols presented rural life in a highly stylized and visually distilled way. This resulted in a sentimental and nostalgic view of life on the farm, which he had experienced as a boy growing up in Nebraska.

In *The Twins*, an oil painting of 1946, Nichols made an archetypal country scene where a farmer returns home in his horse-drawn wagon late in the afternoon on a spring day. By eliminating unnecessary detail, he reduced the composition to its essen-

tial elements—farmhouse, barns, road, earth, and sky. By abstracting natural forms, Nichols's landscape becomes almost sculptural, and the two leafless trees, which give the work its title, create an odd, almost dreamlike quality. Nichols's preference for clean-edged forms and flat pattern further emphasizes the order and harmony of the work to convey an idealized impression of American farm life.

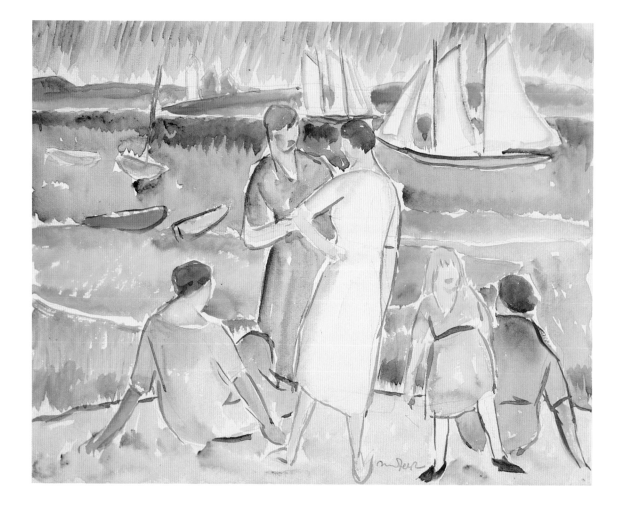

Bror Julius Olsson Nordfeldt
(1878-1955)
*Women on the Shore,
Provincetown*, 1916

Verso: Floral still life
Watercolor and graphite on paper
11⅜ x 14¼ inches
Signed lower right: *Nordfeldt*
Signed and dated, verso: *BJO Nordfeldt
1916*
RLH 186

PROVENANCE
Estate of the artist, 1955
[Zabriskie Gallery, New York]
Richard Lewis Hillstrom, Saint Paul,
196363

EXHIBITIONS
Luther College, Decorah, Iowa, 1968
University Gallery, University of
Minnesota, Minneapolis, 1972, 1982

American Swedish Institute,
Minneapolis, 1976
Saint Olaf College, Northfield,
Minnesota, 1976

REFERENCES
Mary Towley Swanson, *The Divided
Heart: Scandinavian Immigrant
Artists, 1850-1950* (Minneapolis:
University of Minnesota Gallery, 1982),
no. 45.

A noted early modernist painter and
printmaker, Bror Julius Olsson
Nordfeldt explored a succession of
artistic styles to eventually develop
one that would best reflect his formal
concerns. Inspired largely by the
works of Paul Cézanne and Henri
Matisse, he was particularly interested
in the structural and emotional con-
tent of his images and called these ele-
ments the "idea-bones" of his art.

From 1914 to 1918, Nordfeldt
spent his summers in Provincetown,
Massachusetts, where he experimented
with color printmaking and painted
the local landscape with fellow artists
Marsden Hartley, Charles Demuth, and
Marguerite and William Zorach.
Among the works Nordfeldt completed
there were a number of lively improvi-
sations, including the 1916 watercolor
Women on the Shore, Provincetown.
With its broad areas of pure color, inci-
sive outlines, and shallow spaces, the
casual scene reflects Nordfeldt's ongo-
ing fascination with Japanese wood-
block prints and the brilliant palette
and simple forms of the French Fauves.
Through the simple, solid massing of
figures, boats, and water he created a
decorative, harmonious composition
of abstracted forms. Though later he
would abandon this style of painting,
the watercolor nevertheless stands as
an important example of early
American modernism.

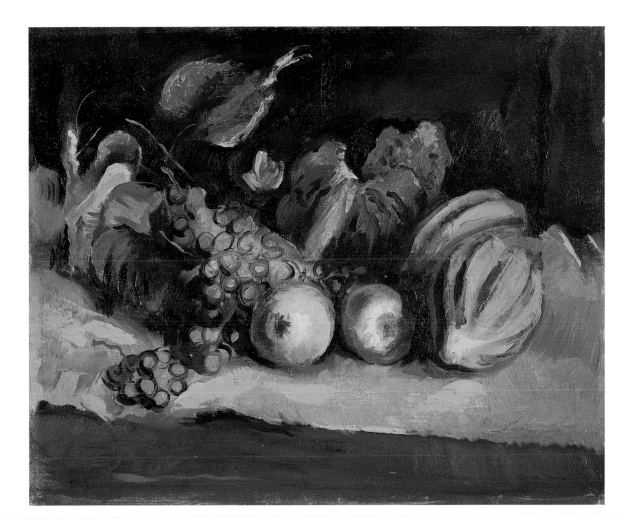

Henry Varnum Poor
(1887–1970)
Autumn Still Life, about
1960–62

Oil on canvas, mounted on panel
16 x 20 inches
Signed lower left: *H V Poor*
RLH 187

PROVENANCE
[Frank K. M. Rehn Gallery, New York]
Richard Lewis Hillstrom, Saint Paul,
1963

EXHIBITIONS
Birger Sandzén Memorial Gallery,
Lindsborg, Kansas, 1972

*I think paintings can die when they
are not seen with loving eyes, and
come to life again when they are.*
—Henry Varnum Poor

Over his long and varied career as an
artist and teacher, Henry Varnum
Poor established himself as a staunch
defender of the realist tradition. A
highly regarded painter in his day,
Poor also was a ceramist, muralist,
designer, and book illustrator. His rep-
utation reached its pinnacle during
the 1930s, when several leading
museums acquired major examples of
his work and a *New York Times*
review hailed him as the equal of "any
living artist anywhere."[1]

As a committed realist, Poor
wrote: "It is only by [an] almost reli-
gious regard for reality that art is con-
tinually revitalized and escapes empti-
ness and bombast."[2] He strongly felt
that artists should use everyday
themes in their work and do so in a
manner that was very personal to
them. Poor's choice of subjects—land-
scapes, figure studies, portraits, and

still lifes—reflected these beliefs.
Influenced by the paintings of Paul
Cézanne, Henri Matisse, and André
Derain, Poor's expressive brushwork
and bold colors imbued his canvases
with a freshness and vitality uncom-
mon in American art of the 1920s and
1930s. His indebtedness to Cézanne is
especially apparent in the style and
composition of his many still lifes,
such as the one here from the early
1960s. Like Cézanne, Poor aimed at
creating tightly constructed realities,
and his flat picture planes and the
solid geometry of his forms further
link him to the earlier master.

[1]Edward Alden Jewell, *The New York
Times* (December 10, 1937): 30.
[2]Peyton Boswell, Jr., *Varnum Poor* (New
York: Hyperion Press, 1941), p. 74.

Maurice B. Prendergast
(1859–1924)
Cottage at Dinard, 1891

Watercolor over graphite on paper
11¾ x 7¼ inches
Signed, dated, and inscribed, lower left:
Prendergast/Dinard/'91
RLH 108

PROVENANCE
Estate of the artist, 1924
Charles Prendergast (the artist's
brother), 1924
Mrs. Charles Prendergast, 1948
[Kraushaar Galleries, New York]
Richard Lewis Hillstrom, Saint Paul,
1957

EXHIBITIONS
Walker Art Center, Minneapolis, 1962
Gustavus Adolphus College, Saint Peter,
Minnesota, 1964, 1987
Saint Olaf College, Northfield,
Minnesota, 1976
College of Saint Catherine, Saint Paul,
1986
Minnesota Museum of Art, Saint Paul,
1986

REFERENCES
Third Exhibition (Minneapolis: Center
Arts Council, 1962).
Carol Clark, Nancy Mowll Mathews, and
Gwendolyn Owens, *Maurice Brazil
Prendergast, Charles Prendergast: A
Catalogue Raisonné* (Munich: Prestel-
Verlag, 1990), no. 521, repr.

NOTE
Maurice Prendergast always kept this
painting for himself, and upon his
death it was inherited by his brother
Charles, who (according to gallery
owner Antoinette Kraushaar) made its
current frame.

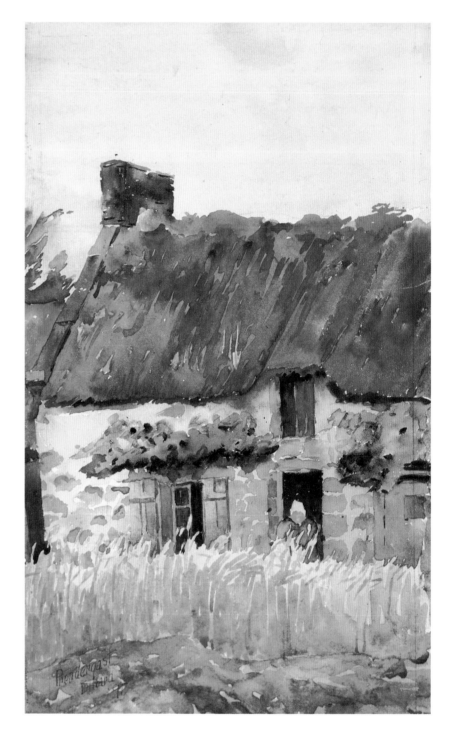

Hailed as America's first modernist, Maurice Prendergast was profoundly influenced during his early career by the flat, decorative patterns and bold colors of such Nabi painters as Edouard Vuillard and Pierre Bonnard. Prendergast studied in France from 1891 until 1895 and was also among the first Americans to use color and form for their emotional qualities. During his student years in Paris, he spent summers in the nearby seaside villages of Tréport, Dieppe, and Dinard, where he completed numerous watercolors of the French countryside. *Cottage at Dinard* dates from this time and was probably a page from one of his sketchbooks. It depicts a modest stone-and-thatch house with a single figure standing in the open doorway. The austere composition, chosen largely for its picturesque and romantic aura, displays the artist's spontaneous technique and decorative application of color. Horizontal bands of contrasting light and dark hues effectively unite the foreground and background of the picture, flattening space and contributing to the mosaiclike buildup of the surface design. Prendergast excelled at making scenes like this, pleasant idylls of people enjoying the out-of-doors, at beaches, in parks, and on the boulevard.

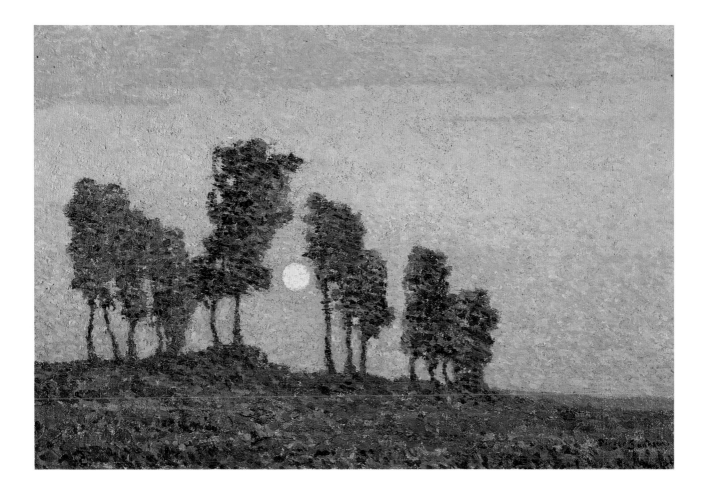

Birger Sandzén
(1871–1954)
Evening, about 1911

Oil on canvas
16 x 24 inches
Signed lower right: *Birger Sandzén*
RLH 166

PROVENANCE
[Grant Art Gallery, Chicago]
Richard Lewis Hillstrom, Saint Paul,
1944

EXHIBITIONS
The Minneapolis Institute of Arts,
Minneapolis, 1976
Minnesota Museum of Art, Saint Paul,
1989
American Swedish Institute,
Minneapolis, 1991

REFERENCES
The American Arts: A Celebration
(Minneapolis: The Minneapolis Institute
of Arts, 1976).

Best known for his Impressionistic
paintings of the Rocky Mountains and
the American Great Plains, Birger
Sandzén was born in Sweden and
trained in Stockholm under Anders
Zorn. Zorn, one of Sweden's leading
modernists, stressed the importance
of color, light, and brushwork to his
young protégé. In 1894, Sandzén
immigrated to the United States and
settled in the Swedish-American com-
munity of Lindsborg, Kansas, where
he taught painting at Bethany College
until his death. While in America, he
traveled extensively throughout the

Far West, sketching and painting the
landscape and carefully noting the
geological and atmospheric character-
istics of each region.
 The oil painting *Evening*, from
about 1911, exemplifies Sandzén's
Impressionist manner. In this lyrical,
subjective interpretation of nature,
intense color and the fleeting light of
early evening become the principal
subject of the painting. Character-
istically, Sandzén relied on small,
rhythmic brushstrokes and the optical
mixing of brilliant hues to achieve his
striking, glowing palette. The rich tex-
ture of the thickly applied paint fur-
ther accentuates the quiet introspec-
tion of the scene. Though the setting
remains unknown, it is likely that
Sandzén completed this work during
one of his many excursions to the
western United States.

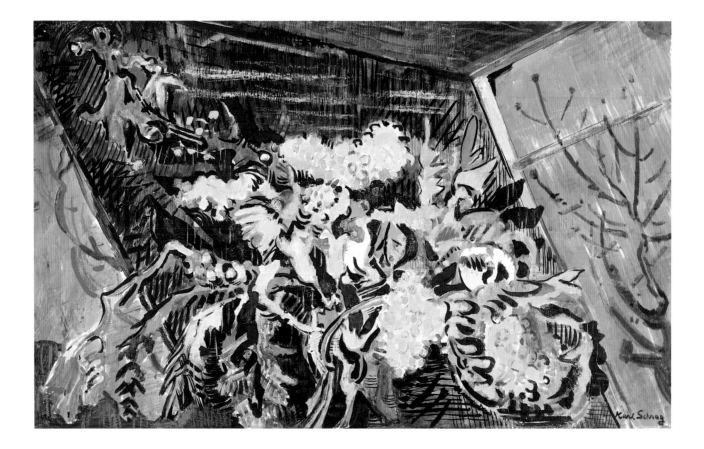

Karl Schrag
(born 1912)
Window at Sunset, about 1951

Gouache on cardboard
16⅛ x 25¾ inches
Signed lower right: *Karl Schrag*
RLH 293

PROVENANCE
Whitney F. Hoyt
[Kraushaar Galleries, New York]
Richard Lewis Hillstrom, Saint Paul,
1970

EXHIBITIONS
Saint Olaf College, Northfield,
Minnesota, 1976
Minnesota Museum of Art, Saint Paul,
1989

*The walls that are supposed to exist
between our thinking and our feel-
ing do not exist in reality . . . it is
impossible to disentangle the knot
which binds the heart and mind
together at all times. Seeing, feeling
and thinking are all combined in
my work as they are in myself.*
—Karl Schrag

An accomplished painter and print-
maker, Karl Schrag made visionary
and lyrical interpretations of nature,
seeking to reveal its essential forms
and universal truths. "Parting from
the specific—flowers, trees, fields or
seas," he once stated, "you can reach
out toward the idea behind the spe-
cific, trying to bring about something
in your work that others will experi-
ence as an echo of what they also
hold as true. . . . I have attempted to
reach toward depth of understanding
both of nature and of myself—and

this never-ending search is reflected
in my work."[1]

The 1951 gouache *Window at
Sunset* demonstrates his interest in
capturing the emotional and spiritual
mood of nature through expressive
forms and colors. Using brilliant
blues, aquas, and yellows, he depicted
a large, exuberant arrangment of
flowers. The bright orange glow of a
setting sun radiates through the
nearby windows, casting dark shad-
ows on the far interior wall. The pic-
ture's odd perspectives, tilted planes,
and shallow spaces further enhance
Schrag's subjective, highly personal
impression of the external world
around him.

[1]Una E. Johnson, *Karl Schrag: A Cata-
logue Raisonné of the Graphic Works,
1939-1970* (Syracuse, N.Y.: Syracuse
University, 1971), p. 9.

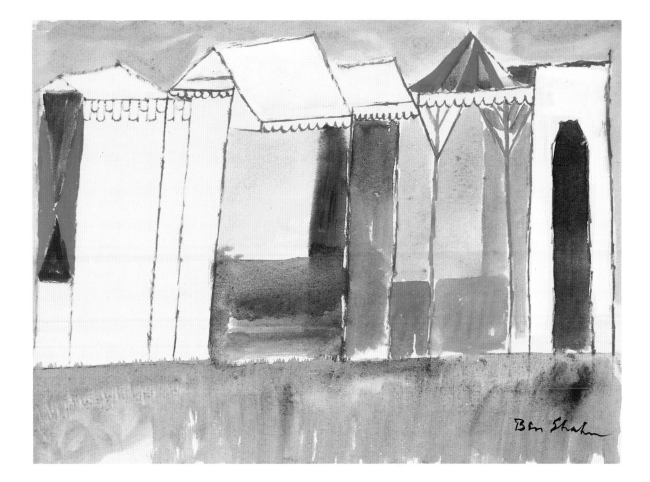

Ben Shahn

(1898–1969)
Carnival Tents, about 1949

Watercolor on paper
8¾ x 12 inches
Signed lower right: *Ben Shahn*
RLH 204

PROVENANCE
[The Downtown Gallery, New York]
Richard Lewis Hillstrom, Saint Paul,
1965

EXHIBITIONS
Saint Paul Art Center, Saint Paul, 1966
Lutheran Brotherhood, Minneapolis,
1975
Saint Olaf College, Northfield,
Minnesota, 1976
College of Saint Catherine, Saint Paul,
1986
Gustavus Adolphus College, Saint Peter,
Minnesota, 1987

*The primary concern of the serious
artist is to get the thing said—and
wonderfully well. His values are
wholly vested in the object which he
has been creating.*
—Ben Shahn

Although Ben Shahn is perhaps best
known as a social satirist, he also pro-
duced many amusing and fanciful
works throughout his career. In the
late 1940s, he began creating his own
greeting cards to send to his family
and friends. Many of these were, in
fact, signed original prints. One of
the earliest, a color screenprint of
about 1948 entitled *Deserted
Fairground*, depicts a group of highly
abstracted carnival tents with geo-
metric designs. Apparently Shahn
had visited the New Jersey State Fair
in Trenton the day after it closed.
The watercolor here may have been
the preliminary study for the screen-
print and is compositionally nearly
identical to it. Both depend for their
decorative effectiveness on the
artist's use of flattened spaces, large
areas of pure color, and simplified
compositions. Several other related
works, completed shortly after the
watercolor and print were made, also
show the quiet loneliness of the
empty fairgrounds.

Everett Shinn
(1876–1953)
Magician with Shears,
about 1915

Oil on canvas
12 x 9⅞ inches
Signed verso: *E. Shinn*
RLH 140

PROVENANCE
Estate of the artist, 1953
[James Graham & Sons Gallery,
New York]
Richard Lewis Hillstrom, Saint Paul,
1961

EXHIBITIONS
The Minneapolis Institute of Arts,
Minneapolis, 1969
Minnesota Museum of Art,
Saint Paul, 1981, 1987
College of Saint Catherine,
Saint Paul, 1986
Gustavus Adolphus College, Saint Peter,
Minnesota, 1987

REFERENCES
Thomas S. Holman, *American Style:
Early Modernist Works in Minnesota
Collections* (Saint Paul: Minnesota
Museum of Art, 1981), no. 68.

An accomplished realist painter and
illustrator, Everett Shinn is best known
for his dramatic scenes of urban life. A
member of The Eight, Shinn began his
career as an artist-reporter in
Philadelphia, where he met fellow
painters John Sloan, George Luks, and
William Glackens, as well as his men-
tor Robert Henri. Perhaps due to his
early training as a visual reporter,
Shinn always remained a fascinated
observer of the human condition and
what he considered to be the essential
moments of life. And although many
of his early works recorded the plight
of the urban poor, Shinn preferred to
depict the city as a bright and ener-
getic spectacle.

Because the theater had intrigued
Shinn since childhood, many of his
most memorable paintings show per-
formers on stage. *Magician with
Shears*, a small-scale canvas from
around 1915, features a magician
preparing to cut a length of fabric.
Portrayed in a strong raking light, the
elegantly dressed magician looks
directly at the viewer, much like a sit-
ter in a formal portrait. Influenced by
his teacher Henri, Shinn established
form through vigorous and sponta-
neous brushwork, an apt technique
that also conveys the vibrancy and
warmth of the magician's personality.

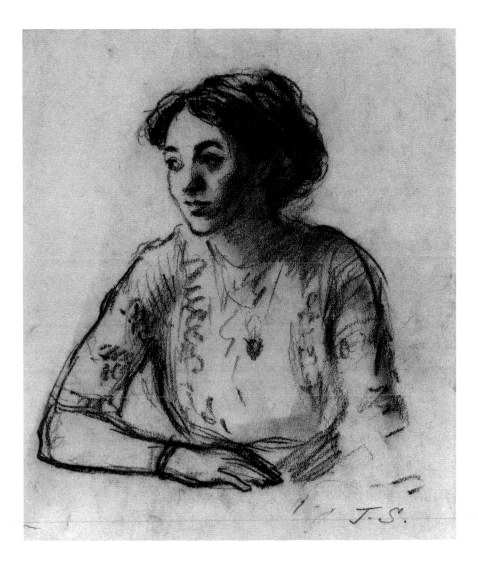

John Sloan
(1871–1951)
*Study of a Young Woman,
Seated*, undated

Verso: Study of a young woman,
seated at a table
Sanguine on paper
11 x 10¾ inches
Signed with initials, lower right: *J. S.*
RLH 106

PROVENANCE
[Parke-Bernet Galleries, New York]
[Kraushaar Galleries, New York]
Richard Lewis Hillstrom, Saint Paul,
1957

EXHIBITIONS
Walker Art Center, Minneapolis, 1964
The Minneapolis Institute of Arts,
Minneapolis, 1971
Lutheran Brotherhood, Minneapolis,
1975
Saint Olaf College, Northfield,
Minnesota, 1976

College of Saint Catherine, Saint Paul,
1986
Minnesota Museum of Art, Saint Paul,
1986
Gustavus Adolphus College, Saint Peter,
Minnesota, 1987

REFERENCES
Collector's Club Exhibition IV
(Minneapolis: Center Arts Council,
1964).
*Drawings and Watercolors from
Minnesota Private Collections*
(Minneapolis: The Minneapolis Institute
of Arts, 1971), no. 50, repr.

*Drawing is one of the three means
of communication between spirits,
like speech and music.*
—John Sloan

As an urban realist and member of
The Eight, John Sloan found his
primary subject matter in the daily
lives of ordinary Americans. A student
of both Thomas Anshutz and Robert
Henri, Sloan began his career in
Philadelphia and for the next twenty-
five years supported himself finan-
cially as an illustrator of books,
magazines, and newspapers. At the
same time, he began painting seriously
in the late 1890s and always sub-
scribed to Henri's credo "to translate
life into art."

This small, undated chalk draw-
ing demonstrates Sloan's virtuoso
draftsmanship. Quickly rendered from
life, the sketch depicts a young
woman seated at a table. Portrayed in
a strong light, she looks away from
the viewer, smiling slightly. With
careful attention to her pose, features,
and facial expression, Sloan conveyed
her essential character and mood in a
straightforward and sympathetic man-
ner. The sketch may have been a pre-
liminary study the artist produced to
accompany one of the many magazine
articles he illustrated.

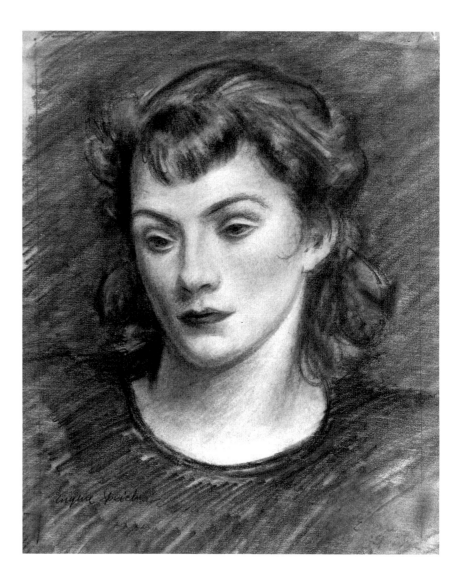

Eugene Speicher
(1883–1962)
Portrait of a Young Woman,
undated

Graphite and charcoal on paper
12⅝ x 10½ inches
Signed lower left: *Eugene Speicher*
RLH 234

PROVENANCE
[Pictoria, Inc., New York]
[Schoelkopf Gallery, New York]
Richard Lewis Hillstrom, Saint Paul,
1967

EXHIBITIONS
State University of New York, Stony
Brook, New York, 1964
Gustavus Adolphus College, Saint Peter,
Minnesota, 1969
University Gallery, University of
Minnesota, Minneapolis, 1974, 1981,
1984
Saint Olaf College, Northfield,
Minnesota, 1976
Minnesota Museum of Art, Saint Paul,
1981

REFERENCES
Donna Isaac, *New York Artists of the
1920's* (Minneapolis: University of
Minnesota Gallery, 1973).
Paul Cummings, *American Drawings:
The Twentieth Century* (New York:
Viking Press, 1976), p. 62, repr.

*Contact: American Art and Culture,
1919–1939* (Minneapolis: University of
Minnesota Gallery, 1981).
Thomas S. Holman, *American Style:
Early Modernist Works in Minnesota
Collections* (Saint Paul: Minnesota
Museum of Art, 1981), no. 71.

*In a well-organized canvas, parts
lose their identity, facts disappear
and miracles happen.*

—Eugene Speicher

A leading proponent of the conservative realism of the 1930s, Eugene Speicher attained distinction for his compelling portraits, especially those of women. Admired for their aura of monumentality and quiet dignity, Speicher's portraits idealized their subjects, while also capturing their innate characters. The 1930s art critic Frank Mather, Jr., believed that Speicher had the ability to depict form from the inside out. This "sense of structure," wrote Mather, is "something more than the vivid and massive assertion of the geometry implicit in the form, as spherical, ovoid or tubular, though it contains that; it is an assertion of the grandeur and importance of the form—a moral as well as an aesthetic quality, the form being after all a symbol of some inherent human dignity."[1] This "grandeur and importance of the form" can be readily seen here in *Portrait of a Young Woman*. Using only graphite and charcoal, Speicher concentrated on the sitter's handsome features and introspective expression. Though the woman's identity remains unknown, her personality has been captured forever in the artist's sympathetic and evocative portrayal of her.

[1]Frank Jewett Mather, Jr., *Eugene Speicher* (New York: Whitney Museum of American Art, 1931), p. 9.

Joseph Stella
(1877–1946)
Flowers in a Glass, 1937

Crayon, colored pencil, graphite, and
silverpoint on prepared paper
12⅛ x 18¼ inches
Signed and dated, lower right: *Joseph
Stella, 1937*
RLH 209

PROVENANCE
Sergio Stella (the artist's nephew)
[Harry Salpeter Gallery, New York]
Richard Lewis Hillstrom, Saint Paul,
1966

EXHIBITIONS
Harry Salpeter Gallery, New York, 1963
Gustavus Adolphus College, Saint Peter,
Minnesota, 1969, 1987
The Minneapolis Institute of Arts,
Minneapolis, 1970
Lutheran Brotherhood, Minneapolis,
1975
Saint Olaf College, Northfield,
Minnesota, 1976
Minnesota Museum of Art, Saint Paul,
1981, 1989

College of Saint Catherine, Saint Paul,
1986

REFERENCES
Thomas S. Holman, *American Style:
Early Modernist Works in Minnesota
Collections* (Saint Paul: Minnesota
Museum of Art, 1981), no. 74.

Joseph Stella's achievements as a
Futurist painter rank him as one of
America's leading early modernists.
A versatile and consummate drafts-
man, he also made thousands of
drawings in a wide range of subjects,
styles, and media. Conceived as inde-
pendent works of art, rather than as
preliminary sketches for other compo-
sitions, these works reveal the vision-
ary romanticism for which he was
known.

Beginning around 1916, Stella
turned his attention to floral still lifes,
the consequence of his new-found
interest in symbolic and mystical inter-
pretations of the natural world. This

drawing exemplifies his fondness for
portraying flowers and his belief that
to make "all our days . . . glide by
serene, sunny, each must begin with
the study of a flower."[1] The simple
composition features two large white
flowers in a glass of water, each ren-
dered with a precision and clarity of
line that captures both their texture
and their form. In contrast, the table-
top, place mat, and background are
more loosely drawn, geometrical
abstractions that accentuate the or-
ganic delicacy of the flower petals and
stamens. A strong raking light washes
across the interior, further emphasiz-
ing the luminous intensity of the
petals, which is created by the
untouched whiteness of the paper
itself. This work, inspired by Stella's
study of Italian Renaissance drawings,
may have been one of several the artist
completed during a stay on the West
Indian island of Barbados in 1937.

[1]Irma Jaffe, *Joseph Stella* (Cambridge,
Mass.: Harvard University Press, 1960),
p. 85.

Mark Tobey

(1890–1976)
Untitled, 1966

Color monotype and handwork on
paper
8¼ x 5¾ inches
Signed and dated, lower right: *Tobey/66*
RLH 244

PROVENANCE
[Seligman Gallery, Seattle]
Richard Lewis Hillstrom, Saint Paul,
1967

EXHIBITIONS
Gustavus Adolphus College, Saint Peter,
Minnesota, 1969
The Minneapolis Institute of Arts,
Minneapolis, 1970
Saint Olaf College, Northfield,
Minnesota, 1976

*An artist must find his expression
closely linked to his individual
experience or else follow in the old
grooves resulting in lifeless forms.*
—Mark Tobey

A noted modernist painter, Mark
Tobey found his artistic inspiration in
the close observation of nature.
Deeply influenced by his nontradi-
tional religious beliefs, in 1918 he
became a member of the Baha'i World
Faith, which emphasizes the spiritual
unity of all people. Tobey, also con-
vinced that the highest reality was
metaphysical, attempted to reveal this
"oneness" in both his art and life.

Over the years, Tobey's paintings
and prints became increasingly non-
representational, and during the 1960s,
he became especially intrigued with
the spontaneity and random effects

afforded by the monotype. By painting
directly on a sheet of glass or metal
and then transferring the still-wet
image onto paper, Tobey produced
one-of-a-kind prints, like the one here.
Part of a large and important body of
work in tempera and watercolor, this
1966 monotype typifies his improvisa-
tional technique. Small in scale and
executed in transparent pinks and
grays, it features an interwoven pattern
of rhythmic, gestural brushstrokes that
gives the composition its overall unity.
Its linear elegance also shows Tobey's
study of Chinese and Japanese calligra-
phy, as does the use of tissue-thin
paper, which enhances the staining
and blotching effects of the water-
based pigments. For Tobey, such
abstractions symbolized the mystical
equality of all forms and the cohesive-
ness of the universe.

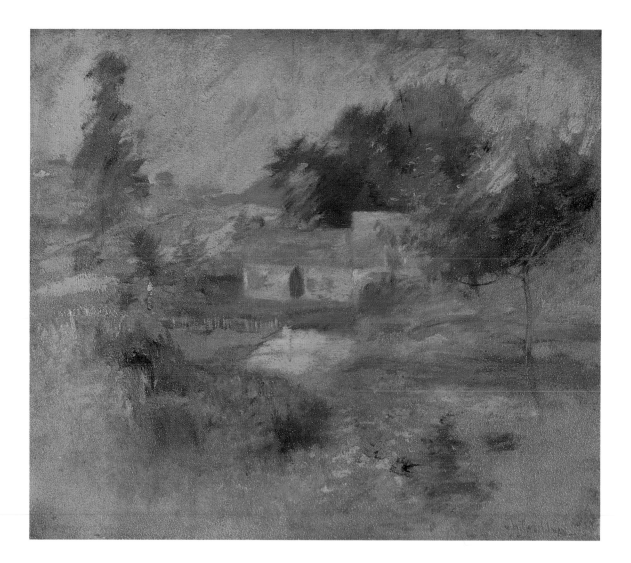

John Henry Twachtman
(1853-1902)
*Spring Landscape
(Greenwich, Connecticut),*
about 1890-94

Oil on wood panel
15⅜ x 18¼ inches
Signed lower right: *J. H. Twachtman*
RLH 119

PROVENANCE
[Milch Galleries, New York]
Richard Lewis Hillstrom, Saint Paul,
1956

EXHIBITIONS
Walker Art Center, Minneapolis, 1957
Gustavus Adolphus College, Saint Peter,
Minnesota, 1957
The Minneapolis Institute of Arts,
Minneapolis, 1969
Birger Sandzén Memorial Gallery,
Lindsborg, Kansas, 1972

REFERENCES
Collector's Club Exhibition (Minneapolis:
Center Arts Council, 1957), no. 139.

As a leading Impressionist and found-
ing member of the Ten American
Painters, John Henry Twachtman
excelled at making atmospheric land-
scapes, especially of his Greenwich,
Connecticut, farm. Twachtman
acquired the property, a seventeen-
acre site on Round Hill Road, in 1890
and lived and worked there until his
death in 1902. The familiar surround-
ings of the farmstead captivated him
and served as inspiration for nearly all
of his late paintings, like the one here.
An oil on panel from the early 1890s,
it shows the artist's house and garden
from an elevated viewpoint known as
the upper terrace. Probably painted in
late spring, this serene work under-
scores Twachtman's interest in the

delicate effects of light and atmos-
phere in the out-of-doors. Rendered
with subtle silver grays and yellow
greens, the composition's blurred
forms and expressive brushstrokes
accentuate the lushness of the awak-
ening landscape.

Thematically, *Spring Landscape*
relates to a larger oil painting called
From the Upper Terrace, which is
now in the Art Institute of Chicago.
That important work was shown in the
first exhibition of the Ten American
Painters in 1898, as well as in all three
of Twachtman's 1901 shows. Which
painting was completed first remains
unknown, since Twachtman rarely
dated his pieces during the 1890s.
Though it is possible that the smaller
panel was a study for the larger one,
differences in color and overall
design indicate that the two were
probably conceived independently of
each other.

Abraham Walkowitz
(1878–1965)
Cityscape: New York Improvisation, 1909

Watercolor on paper
14 x 7¾ inches
Signed and dated, lower right:
A. Walkowitz 1909
RLH 281

PROVENANCE
Estate of the artist, 1965
[Zabriskie Gallery, New York]
Richard Lewis Hillstrom, Saint Paul,
1969

EXHIBITIONS
The Minneapolis Institute of Arts,
Minneapolis, 1969, 1973
Lutheran Brotherhood, Minneapolis,
1975
Saint Olaf College, Northfield,
Minnesota, 1976
Minnesota Museum of Art, Saint Paul,
1981

REFERENCES
Thomas S. Holman, *American Style: Early Modernist Works in Minnesota Collections* (Saint Paul: Minnesota Museum of Art, 1981), no. 78.
Abraham Walkowitz, *Improvisations of New York: A Symphony in Lines* (Girard, Kans.: Haldeman-Julius Publications, 1948), n. pag., repr.

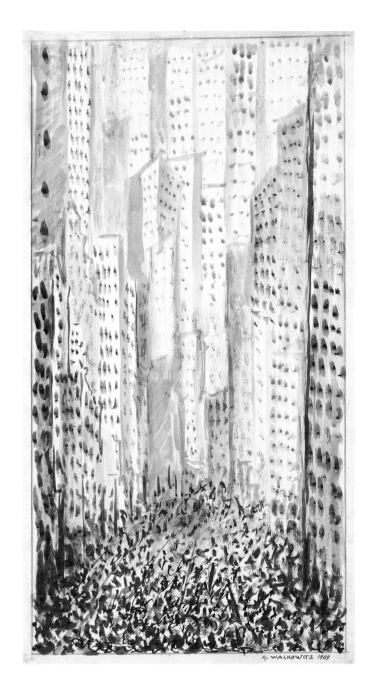

Recognized for his pioneering role in the development of American modernism, Abraham Walkowitz was among the first to assimilate the stylistic innovations of European art into his work. In 1906, while enrolled at the Académie Julian in Paris, Walkowitz met such avant-garde painters as Henri Matisse and Pablo Picasso through Max Weber, an American friend and colleague. Under their influence, Walkowitz returned to New York City in 1907, began painting in a style largely inspired by Matisse's Fauvism, and reestablished his close association with such vanguard artists there as John Marin, Marsden Hartley, Georgia O'Keeffe, and Arthur Dove. This small group had been supported and encouraged by the photographer Alfred Stieglitz, who opened his 291 gallery in 1908 and gave Walkowitz his first solo exhibition in 1912.

Walkowitz experimented with various artistic styles throughout his career. Between 1909 and 1917, he abandoned Fauvism and began to explore Cubism and Futurism. By 1913, after participating in the famous Armory Show and seeing Wassily Kandinsky's abstractions, he created his first nonobjective works. The 1909 watercolor here comes from this early transitional period and is part of a large group of drawings known as the "New York Improvisations," which were published in book form in 1948. The series captures the dynamic rhythms of the city, portraying it as a towering canyon of sky-scrapers awash with surging crowds. "I am seeking to attune my art to what I feel to be the keynote of an experience," wrote Walkowitz in 1916. "When the line and color are sensitized, they seem to me alive with the rhythm which I felt in the thing that stimulated my imagination and my expression. If my art is true to its purpose, then it should convey to me in graphic terms the feelings which I received in imaginative terms."[1]

[1]*The Forum Exhibition of Modern American Painting* (New York, 1916), n. pag.

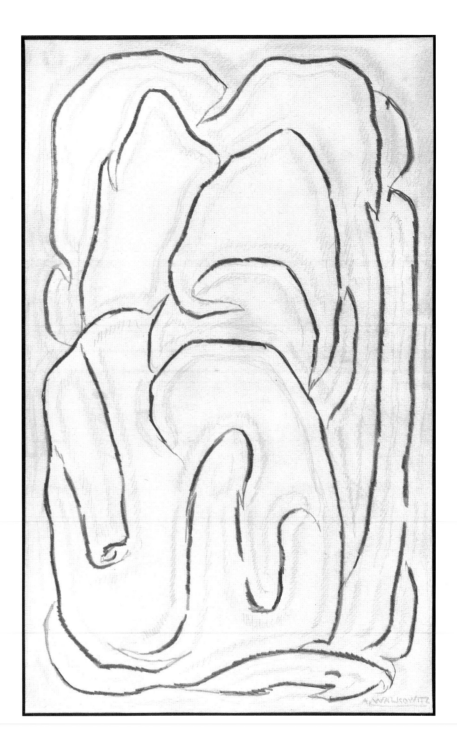

Abraham Walkowitz
(1878–1965)
Abstraction, about 1914

Graphite on paper
17½ x 11 inches
Signed lower right: *A. Walkowitz*
RLH 285

PROVENANCE

Estate of the artist, 1965
[Zabriskie Gallery, New York]
Richard Lewis Hillstrom, Saint Paul,
1969

Abstraction, a graphite drawing of about 1914, thematically relates to Walkowitz's well-known "New York Improvisations." While most of the drawings in the series presented New York in Cubist-Futurist terms, some—like this example—showed the city in totally abstract ways. Here, Walkowitz depicted the cityscape as an organic pattern of billowing, curvilinear forms and agitated lines. This picture derives not so much from a visual interpretation of the hard-edged geometry of New York's buildings and streets as from an emotional response to the rhythm and energy of urban life itself. "Art is creation and not imitation," Walkowitz once stated. "Art has its own life. One receives impressions from contacts or objects and then new forms are born in equivalents of line or color improvisations . . . the artist creates a new form of life."[1]

[1]Abraham Walkowitz, *A Demonstration of Objective, Abstract, and Non-Objective Art* (Girard, Kans., 1945), n. pag.

Elof Wedin

(1901–83)
Factory Town (Anoka, Minnesota), 1939

Oil on canvas
24 x 30 inches
Signed and dated, lower right: *E. Wedin 1939*
RLH 402

PROVENANCE
Acquired from the artist by Richard
Lewis Hillstrom, Saint Paul, 1977

EXHIBITIONS
Hudson Walker Gallery, New York,
1939
Art Institute of Chicago, 1945

REFERENCES
*Fifty-sixth Annual American
Exhibition of Paintings* (Chicago: Art
Institute of Chicago, 1945), no. 153.

Born in Sweden, Elof Wedin immi-
grated to America in 1919, eventually
settling in Minnesota, where he lived
and worked for much of his life.
Trained at the Art Institute of Chicago
and the Minneapolis School of Art
(now the Minneapolis College of Art
and Design), Wedin always chose sub-
jects from his immediate environ-

ment, including rural landscapes,
small-town views, industrial sites,
river scenes, and portraits.

Factory Town, a 1939 oil painting
of the riverfront in Anoka, Minnesota,
shows Wedin's enduring interest in
Paul Cézanne's system of pictorial rep-
resentation. Here, Wedin recorded a
complex of sunlit industrial buildings
as an abstracted arrangement of sim-
ple, geometric forms. Using broad,
angular patches of thick, unmodulated
color, he simultaneously emphasized
both the underlying structure of the
architecture and the surface pattern of
the composition. An important work
in the artist's oeuvre, the painting has
a frame carved by Wedin himself.

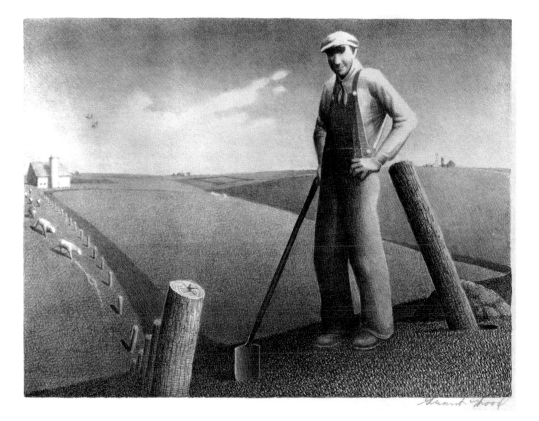

Grant Wood
(1892-1942)
In the Spring, 1939

Lithograph on wove paper, edition of
250
9 x 11⅞ inches (image)
12 x 16 inches (sheet)
Signed beneath image, lower right:
Grant Wood
Gift of Richard L. Hillstrom in memory
of the Reverend Ralph R. Lindquist, The
Minneapolis Institute of Arts P.84.43

PROVENANCE

[Associated American Artists Gallery,
Chicago]
Richard Lewis Hillstrom, Saint Paul,
1945
The Minneapolis Institute of Arts, 1984

EXHIBITIONS

The Minneapolis Institute of Arts,
Minneapolis, 1970, 1990
Lutheran Brotherhood, Minneapolis,
1975
University Gallery, University of
Minnesota, Minneapolis, 1976 (exhibi-
tion traveled to Carleton College,
Northfield, Minnesota; Rochester Art
Center, Rochester, Minnesota; Noble
County Art Center, Worthington,
Minnesota; Willmar Community
College, Willmar, Minnesota; Owatonna
Art Center, Owatonna, Minnesota;
Winona Art Center, Winona, Minnesota;
Metropolitan Community College,
Minneapolis; Cedar Rapids Art Center,
Cedar Rapids, Iowa)
University Gallery, University of
Minnesota, Minneapolis, 1981, 1983

REFERENCES

James M. Dennis, *Grant Wood: A
Study in American Art and Culture*
(New York: The Viking Press, 1975),
no. 183, repr.
Mariea Caudill, *The American Scene:
Urban and Rural Regionalists of
the '30s and '40s* (Minneapolis:
University of Minnesota Gallery,
1976), no. 12, repr.
*Contact: American Art and Culture,
1919-1939* (Minneapolis: University of
Minnesota Gallery, 1981).
*Images of the American Worker,
1930-1940* (Minneapolis: University of
Minnesota Gallery, 1983).

One of the leading regionalists of
the 1930s, Grant Wood helped lead
the effort to develop an indigenous
American iconography, independent
of European and urban influences. In
a highly refined realistic style, Wood
depicted idyllic scenes, largely from
his experiences in rural Iowa. Often
mythical in character, his works
emphasized the basic values and
heritage of America's heartland.
Though he did not make his first litho-
graph until 1937, by then quite late in
his career, he did complete nineteen
prints during the last five years of
his life.

In the Spring, a lithograph of
1939, typifies Wood's agrarian
themes. The print shows a farmer
standing alone on a hillside before a
sweeping vista of open countryside,
momentarily resting while setting
fence posts. Though humble in
appearance, he stands confidently,
hands on hips, looking directly at the
viewer as if posing for a snapshot.
Here, Wood presents the farmer as a
heroic, independent figure, quietly
watchful over his domain. Unlike
many of his contemporaries, who
made freely drawn images, Wood
used the lithographic crayon in a
highly controlled manner, establishing
form through short linear strokes
that permitted very subtle variations
of tone. The composition also
possesses an overall simplicity and
harmony, qualities Wood associated
with the traditional values of the
American farmer.

Marguerite Thompson Zorach

(1887–1968)
Provincetown, about 1916

Graphite on paper
12⅞ x 12⅝ inches
Signed lower left: *Marguerite Zorach*
Inscribed lower right: *Provincetown*
RLH 247

PROVENANCE
[Kraushaar Galleries, New York]
Richard Lewis Hillstrom, Saint Paul,
1967

EXHIBITIONS
The Minneapolis Institute of Arts,
Minneapolis, 1969
Lutheran Brotherhood, Minneapolis,
1975
Saint Olaf College, Northfield,
Minnesota, 1976

With her return to the United States
from Paris in 1912, Marguerite Zorach
began an important, though short-
lived, career as a modernist painter.
Influenced by the Fauves and German
Expressionists, Zorach received early
recognition in New York art circles
for her joyful, boldly colored land-
scapes. Her reputation in the van-
guard was further enhanced after she
participated in the 1913 Armory
Show, the 1916 Forum exhibition,
and the 1917 Society of Independent
Artists exhibition, all three landmark
exhibitions in the development of
American modernism.

In a notable departure from her
early Matisse-inspired paintings,
Zorach began experimenting with
Cubism in 1916. She spent that sum-
mer in Provincetown, Massachusetts,
with her artist-husband, William

Zorach, and created a significant num-
ber of paintings and drawings in the
Cubist style. Cognizant of the work of
Pablo Picasso, Georges Braque, and
Max Weber, she effectively used such
Cubist elements in her art as flattened
geometric forms, multiple view-
points, and fragmented objects. This
small-scale study comes from that
period and shows the truncated
rooftops, steeples, and buildings of
the popular resort town. An impor-
tant oil painting, also with the same
title and date, exists and is character-
ized by a similar fragmented architec-
ture. Yet no direct link between the
two works can be established.
Indeed, reconstructing Zorach's early
history remains complicated by the
fact that at several times during her
career she destroyed whole groups of
her paintings.

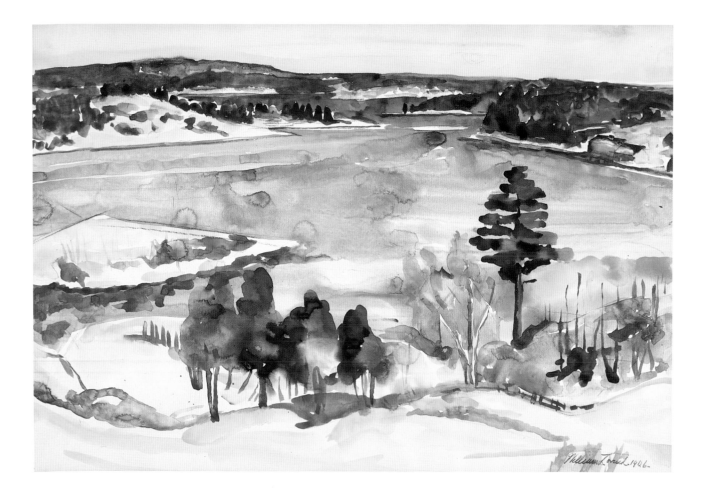

William Zorach
(1887-1966)
Maine Landscape, 1926

Watercolor on paper
15¼ x 22⅜ inches
Signed and dated, lower right: *William Zorach 1926*
RLH 198

PROVENANCE
Mrs. Malcolm McBride
[Kraushaar Galleries, New York]
Richard Lewis Hillstrom, Saint Paul, Minnesota, 1964

EXHIBITIONS
Luther College, Decorah, Iowa, 1968
The Minneapolis Institute of Arts, Minneapolis, 1971
University Gallery, University of Minnesota, Minneapolis, 1974
Lutheran Brotherhood, Minneapolis, 1975
Saint Olaf College, Northfield, Minnesota, 1976
College of Saint Catherine, Saint Paul, 1986
Gustavus Adolphus College, Saint Peter, Minnesota, 1987

REFERENCES
Drawings and Watercolors from Minnesota Private Collections (Minneapolis: The Minneapolis Institute of Arts, 1971), no. 71, repr.
Donna Isaac, *New York Artists of the 1920's* (Minneapolis: University of Minnesota Gallery, 1973).

Though best known today for his monumental stone and wood sculptures of mothers and children, William Zorach began his career as a painter. During the 1910s, especially, he produced canvases dominated by Fauve and Cubist influences. In 1922, he abandoned oil painting altogether, along with many of his modernist tendencies, and devoted his full attention to sculpture. To escape the physically demanding regimen of stone carving and to provide a more spontaneous outlet for his enjoyment of nature, Zorach painted watercolors during the summers he spent at his Maine farm on Georgetown Island. Reflecting both a deep love of the out-of-doors and an admiration for his picturesque surroundings, he made scenes that conveyed the serenity and beauty of the coastal region. *Maine Landscape*, a watercolor of 1926, typifies his work in this medium. Done in a traditional, wet-wash technique, the watercolor features cool, clear colors and a luminous presentation of light. Although the exact locale of *Maine Landscape* remains unknown, it may be Robinhood Cove, an inlet adjacent to Zorach's farmstead.